Loredana Parmesani

Art
of the Twentieth
Century

Movements, Theories, Schools
and Tendencies 1900-2000

Skira editore / Giò Marconi

Graphic Design
Marcello Francone

Editorial Work
Claudio Nasso

Layout
Monica Temporiti

Translation
Rhoda Billingsley

Photos
Archivio Skira

Cover
Man Ray, *Palettable*, 1941-1971
Painted palette on three feet,
87.5 × 51.5 × 61.5 cm
Giorgio Marconi collection, Milan

First published in Italy in 1998 by
Skira editore S.p.A.
Palazzo Casati Stampa
via Torino 61
20123 Milano
Italy

Printed and bound in Italy. First edition.

ISBN 88-8118-652-7 (paperback)
ISBN 88-8118-688-8 (hardcover)

Distributed in North America and Latin
America by Abbeville Publishing Group,
22 Cortlandt Street, New York, NY,
10007, USA.
Distributed elsewhere in the world by
Thames and Hudson Ltd., 181a High
Holborn, London WC1V 7QX, United
Kingdom.

Art of the Twentieth Century

Contents

Introduction

In the exhibition "Anni sessanta" in the summer of 1996, a work by Christo, *Barrels*, was on display on the ground floor of the Galleria Giò Marconi in Milan. I happened to be standing near some visitors and overheard them as they remarked how harmonious the colours of the barrel lids were that Christo had piled up and how clever the artist had been in creating his composition. That was when I realised that the time had come for gallery owners to provide explanations about the works of art, and to be as clear and as informative as possible. There was a card on the wall which gave the artist's name, and the title, date of execution and dimensions of the work but there was no key to help the viewer to "enter" the work.

Just what does the average gallery-goer know about Neo-Dada, Nouveau Réalisme, or the other art terms and movements that have followed close upon one another particularly in this century? If the ideas behind those works are unknown, then an understanding of the different historical moments becomes difficult and at times arbitrary. It occurred to me that a small vademecum was necessary, a pocket manual that would serve as an introduction to the world of art of this century, an informative handbook rather than a volume of serious art criticism. A valid instrument for the viewer to walk, without feeling lost, through the field of contemporary art. Therefore, I spoke first to Loredana Parmesani, a young and attentive art critic, about my idea, and she agreed to write such a book. And then I turned to Massimo Vitta Zelman of Skira. And here is the result: *Art of the Twentieth Century – Movements, Theories, Schools and Tendencies 1900-2000*. We all hope that this book proves useful—and why not?—even necessary to those who frequent the world of contemporary art.

Giorgio Marconi

Preface

" Never before has such universal confusion prevailed regarding a knowledge of modern and contemporary art as it does today, and it is easy to explain why. The media, television, newspapers, and even books and magazines, which have renounced their mandate to educate the world in order to increase the circulation of scandal and gossip, have deprived art of its spirit of sportsmanship and healthy re flection, and its love of intelligent workmanship which had made it a bulwark of humanism."

However, this confusion is not only due to the media. The schools are equally responsible, especially the art schools, as are the cities with their museums which are more interested in increasing the numbers of their subscribers and visitors for their own political purposes. They have all created such a confusion that at this moment many works that are of decisive importance to the history of modern art seem to count for less than those of some of the so-called artists.

All this has provoked an acceleration of exhibitions that have nothing to do with art. Indeed, not only are artists multiplying like mushrooms, but many private galleries are also springing up, just like those art critics who as soon as they can sign a column in a newspaper feel they are free to say whatever they please about art, for they are convinced that the public they are addressing will have nothing to object to since it often knows nothing. In such a system, art does not seem to have anything supporting it.

Yet, art does conceal theories. While people look at a painting or sculpture attentively and often untiringly, no one seems to see what really counts, what lies behind the immediately visible, and putting

on one's glasses to read the label that lists the important national or international exhibitions the work has been in serves no purpose because the value of the work cannot be seen, it can only be known, and that knowing is not mysticism, it is simply a concrete fact.

The simple act of looking at art which we all can experience has never been the realm of the ignorant, but rather that of the cultivated eye that can allow itself to be seduced and identify with the work because it has been trained.

If I say this, it is because the last thing I want to do is ruin the pleasure of looking, the drama of the brushwork. I only wish to point out that this pleasure comes from experience and from knowing what lies behind what we are looking at. This is not only true for art, it is true for everything in this world. That is why it is better to know some basic things before delighting in what you see.

One of the aims of this book is to discover what one does not immediately see behind the beautiful or ugly forms of modern art: the historical motivation which is never subjective since it is rational and objective and therefore comprehensible to everyone.

Another motivation is the fact that modern art, because it works with pictorial language, does not put up easily with imitations and the imitators of a work or an artistic movement who have only superficially understood the aesthetic play of the forms and not the real problems of the work: the necessary invention.

Today, it is certainly easy to create pleasing works with informal brushstrokes, just as it is easy to obtain beautiful artwork by using the techniques of the disappearance of the object so typical of Conceptual Art, but even those who are sure of their own drawing ability and technical virtuosity and show that they can paint as well as the best of the Neo-classicists are still not convincing. In spite of the ostentatious aestheticism, it all appears timid and terribly silly. Modern art has been much more than a beautiful appearance. This book intends to throw light on what has been neglected in recent years, the theory behind the work. That is why, when Giorgio Marconi, whom I thank for his encouragement and for his precious advice, suggested some time ago that I write a book about the artistic movements of the twentieth century, one that would be simple and essential, clear and precise, I accepted willingly.

This book is meant to be a handy manual which may perhaps be of use to all those, the young and the not so young, the cultivated and the still culturally uncertain, professionals and students, who wish to understand what art has been in our century and what it still repre-

sents today. Naturally, this work does not pretend to be exhaustive, nor does it propose a critical theory for reading the past and the present.

I hope that its simple, synthetic structure will prompt further investigation, promote a broader view, and win over to the joys of art those who up to now have stopped at its surface, and in recent years, only at the spectacle and performance it has been turned into.

This book does not analyse the many important artists and the works they have created in this century: what it does is examine the artistic concepts and theories which have influenced them and contributed to making them so extraordinarily vital even amidst so much inconsistency in achievements.

The choice of artists taken into consideration is strictly relative to the description of the different movements. Therefore, many important figures do not appear since they do not fit into the categories of the different aesthetic movements, although they are significant because of their autonomous research. Apropos of this, a second volume might be useful in order to better clarify the highly complex and controversial historical period which has marked the century that is about to close. "The artistic movements, both major and minor, analysed here have all brought about changes in the language of art that were essential because they made it possible to confront contemporary art with a surer and less ingenuous eye. "

Today, art is no longer characterised by the birth of movements, no longer does it move according to concepts that refer to the known and aesthetics that tend towards universality, but it proceeds subjectively as it laboriously attempts to construct a new language.

I wish to conclude this book with a view of contemporary art that remains suspended because what is presented before our eyes is no longer the result of objective research. It is a thoroughly new attempt, surprising and exciting, to question such new terms as subjectivity in order to discover a new language, one that is still difficult to say what it will be.

L.P.

The Continuation of the Nineteenth Century and the Breakthrough: Toward the Avant-garde Movements

While it can be said that a complete revolution in the language of art has been brought about during the twentieth century by means of the cogent theories of the historical avant-garde movements and the subsequent revival of these by neo-avant-garde movements after the Second World War, it is equally true that the nineteenth century witnessed a decisive renewal and radical transformation of the language and techniques of modern art.

When Neo-classic and Romantic research joined forces in the prevailing academic climate of the official Salons which were going through a crisis during the middle of the nineteenth century due to the discovery of photography as an instrument for reproducing reality, some artists started to search for a language that would be innovative on the one hand with respect to that of the academy, and on the other, respond to the ever-increasing presence of mechanically produced images.

"Jean-Baptiste-Camille Corot, Gustave Courbet, and Edouard Manet, together with other contemporary artists, began their pictorial research by defining a program that was headed in the direction of "total realism", where reality was to be confronted as it was, and not according to some preconceived idea." The artistic world in Paris in particular began to orient itself in an anti-academic direction regardless of the individual preferences of each artist, favouring the kind of research in which reality, the landscape or the still life, were to be considered how and where they really were, far from the ateliers and in direct contact with nature.

The practice of painting in *plein air*, which was employed by the Impressionist painters in particular, became for many a new way for

understanding their relationship with reality and its pictorial representation.

The Impressionist movement which started during the 1860s and held its first exhibition in 1874 was in sharp contrast with academicism. It adopted a naturalistic painting based on the fleeting (retinal) impression that an object, transmitted by light, left on the eye of the painter who then transferred it to the canvas by means of touches of pure colour. The discovery by the Impressionist artists (Claude Monet, Paul Cézanne, Edgar Degas, Pierre-Auguste Renoir, Camille Pissarro, Alfred Sisley) of pure colour and the infinite possibilities of complementary colours, their rejection of chiaroscuro and of black as the absence of light (theirs was the introduction of coloured shadows), caused an upheaval in the way painting was considered up to that time. Impressionist painting, practised in the open air and in direct contact with nature, attempted to transpose the artist's immediate impression onto the canvas through light and colour.

In the beginning of the 1880s, the Impressionist movement suffered a crisis which led some artists to undertake new paths of research which resulted in Neo-Impressionism, also called Pointillism or Divisionism. Its two major representatives, Georges Seurat and Paul Signac, created works in the mid-1880s in which there was a strong theoretical plan and a rigorous pictorial technique based on the division of colour according to the scientific laws of optics. The Neo-Impressionist works, unlike the mutable, evanescent Impressionist ones, were constructed in a rigid scientific fashion, and the pure, primary colours were placed on the canvas with small dabs or touches whose dimensions were in proportion to the dimension of the canvas itself. The coloured dots that comprised the work blended in the eye into an infinite polychromy.

Symbolism developed simultaneously to Neo-Impressionism, and in smooth antithesis to it. This movement intended to go beyond the purely visible system of Neo-Impressionism by developing its research in a more mystical direction. Gustave Moreau, Pierre Puvis de Chavannes, and Odilon Redon, together with the poets Stéphane Mallarmé and Jean Moréas, who defined its theories in literary circles, proposed the need for an art, like poetry, that would "take on the idea of a sensitive form", which meant re-establishing the primacy of inner reality over that of the external, the objective, the concrete. By rejecting Impressionist pictorial naturalism, and the works of Zola in literature, they defined art as an evocation of indefinable

and fluid moods that could only be expressed by the suggestion of colour, the sinuosity of line and the musicality of poetry.

But during the last two decades of the nineteenth century other artists, although not organised into movements, were also working autonomously in researches that were equally important to those expressed by the different groups, and they too established a base from which the movements and artists of the twentieth century would depart. Vincent van Gogh, Edvard Munch, Paul Cézanne, Paul Gauguin, and Henri Rousseau represented, perhaps better than others, that singularity that would be a bridge between the two centuries and they set the premises through their works for what would occur during the early years of the new century.

Van Gogh, whose painting was charged with chromatic tension and expressive force, became such an important reference point for the young French artists who started the Fauves movement at the beginning of the century that one of them, Maurice de Vlaminck, declared him to be the master artist. At the same time, Munch, a tormented, tragic Nordic, was tracing out the path through his works that led to Die Brücke (The Bridge), the most important group of German Expressionists who shared the Norwegian artist's tension-charged painting, a form and colour that denounced the drama of the subject and society. And lastly, Cézanne who during his long and solitary years at the foot of Montagne Sainte-Victoire laid the foundations for Cubism. The twentieth century therefore opened with movements that introduced the avant-garde and called themselves revolutionary, but their roots lay deep in the important languages of art of the preceding century. The avant-garde was, on the one hand, a breakthrough with the past, an attempt to completely revolutionise not only art but also culture and society; but on the other hand, it was also in some cases a looking back at the past in order to try to find ideas and resources. The avant-garde movements of the beginning of the century therefore opened onto a new world with theories that were more and more adventurous and revolutionary, ones that experimented daring and audacious techniques in an attempt to give art a reason for its existence in a world that was changing more and more rapidly.

Modern art, which in the nineteenth century had raised the question of its own languages and techniques and totally renewed its own statues, found in the twentieth century, thanks in particular to the avant-garde movements at the turn of the century, the strength to seek increasingly radical ways to establish itself as a new language that could even affect reality.

Expressionism

Expressionism was an artistic movement that developed about 1905 in Germany with the Die Brücke group (Kirchner, Heckel, Schmidt-Rottluff and later Nolde), and in France with the Fauves (Matisse, Derain, Dufy, van Dongen, Vlaminck, Braque). Expressionism, however, is to be considered above all as a European cultural climate that involved all areas of artistic research, from painting to music, from literature to the theatre, from photography to the cinema. In the world of painting, it was marked by the violence of line and colour. The Expressionists criticised Impressionist painting which represented images of what the eye perceived on canvas by means of the play of light and colour, and chose instead to interpret the drama of life and the crisis of social and national ideals (above all, the German painters) by means of a violence of form bordering on the monstrous. For them, expression was feeling through action and the work of art was the result of an action that the artist impressed on the canvas. Expressionist painting no longer wished to represent the world, it chose to live it through the direct experience of subjective drama, "to express it", as indeed the word signifying that movement means.

During the first decade of the twentieth century, Europe was beset by a profound crisis of all the cultural, political and social ideals that had been sanctioned during the preceding century. The questioning of those beliefs, which Impressionist painting had resolved in art through a purely superficial and retinal vision of reality, forced some artists to start exploring in the opposite direction.

In 1905, the Die Brücke (The Bridge) group was formed in Dresden by four Polytechnic students (Ernest Ludwig Kirchner, Erich Heckel, Karl Schmidt-Rottluff and Fritz Bleyl). They were joined the following year by Max Pechstein, whose research lay in sculpture, and Emil Nolde, whose rural background contrasted with the intellectualism of Kirchner, and whose art still expressed a romantic feeling of harmony with nature and mystic-religious tendencies.

Through their common vision of the world, the members of the group criticised and undermined the bourgeois beliefs of the industrial society which had been the pillars of the latter half of the previous century. Their objective was to modernise art and together with it the entire world by means of aesthetic practice. Starting from an analysis of primitive cultures, whose hard, incisive forms they appre-

16

ciated, and the paintings of Edvard Munch who can be considered the precursor of the movement, as well as from the popular German tradition of xylography (wood engraving), they sought a strong and volitive, almost violent, expressive autonomy.

By exploiting contemporary historical tensions and drawing inspiration from them, the German Expressionists rebelled against the production mechanisms of modern times with their vitalistic energy of which the work of art was an instrument and result. By the use of harsh, deformed figures, that were violent both in line and colour, and by the abolition of all symbolism, they proposed a vision of the world that was objective and subjective at the same time, in which the objective was the actual act of creating art and the subjective was the artist's will and intention with which he confronted reality and transposed it to the canvas. This resulted in figures of exaggerated shapes, foreshortened perspectives and almost photographic cuts, intense, unnatural, almost unpleasant colours, and with a line circumscribing the forms that stressed the dramatic quality of the work and the creative effort of the artist.

Technique was no longer the expression of sophisticated, skilled manual dexterity, it was work, a physical effort that was visible on the canvas. In this regard, it is interesting to note the use of xylography, which Kirchner had also employed in the publication of the Brücke manifesto. This old and popular technique, so typical of the Nordic cultures, was most effective in demonstrating how difficult it was to create an image, how much effort was required to construct a form. The hand that carved wood exerted itself physically and that exertion gave life to the work.

Unlike the Germans, the French Fauves (wild beasts) were a much more heterogeneous group that counted among its numbers Henri Matisse, Kees van Dongen, Raoul Dufy, André Derain, Maurice de Vlaminck and Georges Braque. Although they shifted the problem to a less dramatic and more vitalistic direction, one that came close to the "life force" theorised by the philosopher Henry Bergson, the Fauves were, however, alert to all aspects of existence characterised by elements of balance and serenity. Their common aim, although not programmed, was to rebel against the decorativeness of Art Nouveau and the spiritualistic excesses of Symbolism.

The early years of the twentieth century in France were marked by cultural and social convictions that originated from the great humanistic tradition, and it was inevitable therefore that Matisse's and the other Fauves' view of the world would embrace the positive and

vitalistic aspect of reality above all. Notwithstanding this, their work was immediately criticised in official circles as being violent and wild. The term "fauves" was used in a negative sense because of the violent pictorial language the artists employed. The French, who were no longer interested in Impressionism, Symbolism and the mysticism that had been such a rage at the end of the previous century, had also turned their eyes to the work of Vincent van Gogh in particular which was clearly anti-Impressionist and the relationship he had established between art and life, as well as that of Paul Gauguin. The Fauves created paintings of extraordinary intensity, with dazzling colours applied by means of a rapid expressive technique that paid its own debt to Neo-Impressionism, but also by searching for a "gay science" of vision. Their subject matter was limited to nature, the city with its bustling life, the interior of a house, the intensity of a portrait. In 1905, Matisse painted *La Joie de Vivre*, the culmination of his artistic output: in a calm and voluptuous setting of nature, nude figures are gathered in small groups, playing, resting, conversing, loving, living in complete and perfect harmony with the landscape. For Matisse, the joy of living was the ability of painting to give life to a work planned in perfect equilibrium, an almost classical equilibrium in which all the elements that composed it seemed to express the greatest happiness. Matisse's choice of colours, as with all the Fauves and unlike the Germans of Die Brücke, tended to be pure and luminous ones which created the extraordinary harmonies that contrasted sharply with the intense dissonance of Kirchner.

For the French, colour was an instrument for seeking balance and harmony. And expression was not so much the staging of a drama, be it of an individual or of history, as it was for the Germans, as the continuous search for the harmonic structure of a painting, and an intensely chromatic style. Matisse himself wrote: "Expression, for me, does not consist of the passion that suddenly appears on a face or is revealed by a violent gesture. It is to be found in the whole arrangement of my painting: the place occupied by the figures, the empty spaces around them, the proportions, all of that is important."

Cubism

This term indicates the movement that developed in Paris about 1908 from the researches of Picasso and Braque, to which Juan Gris adhered in 1911. Starting from an analysis of Cézanne's painting in which Impressionist chromatism was transformed in-

to the solid volumes of the object, and from the study of primitive Negro sculpture, the two artists began to question Renaissance perspective. They resolved it in a plastic spatial structure in which the different points of view of the object were reconstructed on a single plane, thus depicting simultaneously a frontal and profile view of a face together with one from the top to the bottom. Cubism was divided into two fundamental periods: 1) Analytic Cubism in which the subject was analysed and fragmented, and subsequently reconstructed on the canvas in a multitude of superimposed planes so as to render it pictorially in its entirety; 2) Synthetic Cubism in which the subject returned, thanks also to the contribution of Juan Gris, to a formal, compositional order of rational, geometric character in which the structure of the painting was conceived as pictorial architecture.

In the genesis and maturation of Cubism, three factors played fundamental roles: 1) the work of Paul Cézanne, from *The Card Players* (1890-92) to the *Montagne Sainte-Victoire* (1904-06) in which geometric forms became mental instruments for a totally new pictorial adventure; 2) the arrival of African art in Europe, in particular Negro sculpture; 3) the works of Henri Rousseau 'le Douanier' who in paintings like *The War* (1894) and *The Snake Charmer* (1907) reacted like a naive visionary against the excessive formalism of late nineteenth century art.

Cézanne's work revealed to his contemporaries, above all the younger artists like Picasso, a strong vigorous painting that explored the reality beyond the visual sensation and rejected the Impressionist use of colour in order to arrive at its most profound structure. His painting was based on analysis and geometric synthesis, and his objective was "to treat nature by means of the cylinder, the sphere, the cone, with everything in perspective." From this arose the necessity to introduce vibrations of light, represented by reds and yellows and by a sufficient amount of bluish colouring "to feel the air." In many of the works that Cézanne painted after he left the Impressionists, for example, the *Montagne Sainte-Victoire* series or the *Bathers* (1898-1905), the balance and rationality of the forms were stressed and even space was treated like form, becoming an object in which to place reality: his painting was all space.

With regard to African sculpture, it should be underlined that because of Europe's colonial, expansionistic policy, it looked on the African territories not only as areas for political and economic conquest but

also as areas of "culture" which could offer handwork of extraordinary formal strength. Negro sculpture, when considered as an object in its pure formal reality, is the antithesis of Cézannian painting. While the Aix-en-Provence master concentrated exclusively on space, a space that became all one with the objects by incorporating them and assimilating them, Negro sculpture is all object, an object completely closed to space which is an absolute void as far as it is concerned. This antithesis led Pablo Picasso to produce a painting that broke with every pictorial convention. It was powerful, vigorous, and almost wild, but it was extremely clear in confirming its need to exist. In *Les Demoiselles d'Avignon*, the fundamental Cubist work that was begun in 1906 and finished in 1907, Picasso determined the exact terms of the synthesis. By maintaining the solid formal plan of Negro sculpture, the Spanish artist, using vigorous brushstrokes, opened the solidity of the volumes and the pictorial planes of the figure to the space containing it which, as with Cézanne, became a construction that related the interior with the exterior, and in this way singled out the zero point or *tabula rasa* for a new beginning.

The third element to consider in order to understand Cubist research, although it may appear far-fetched, is Rousseau's work. His technique was precise and painstaking, and anything but academic in its naivete. It made a *tabula rasa* of all the traditional techniques of representation by taking art back to the zero degree and questioning everything that had preceded it. This "zero degree" was Picasso's departure point.

Problems such as these prompted his research which resulted in Cubism, thanks also to his close collaboration with Georges Braque who, having left the Fauves after his meeting with Picasso and his *Demoiselles*, devoted himself entirely to the new pictorial language. Between 1907 and 1908, Braque painted *Standing Nude* in which Picasso's lesson was clearly evident, and in the summer of 1908, he painted a series of landscapes at L'Estaque, later exhibited in Paris, in which all the elements were reduced to elementary geometric forms. From 1908 on, the two artists were in daily contact and Cubism was already being talked about, ironically at first by the critic Louis Vauxcelles, and by Matisse who remarked that Braque's landscapes had been painted with "little cubes". However, in a very short time Cubism was written about in terms of appreciation and esteem by the poet and writer Guillaume Apollinaire, who was close to the movement during its evolution, in the introduction to *Les peintres cubistes* (1913): "the new school of painting has taken the name of Cubism…"

Starting with Picasso's and Braque's collaboration in 1908, the first period of research that resulted was described as Cézannian or analytic. The pictorial problem for the two artists concerned the actual plane of the painting, which was so loaded with historical references. It was a theoretical but also a concrete plane with a given base and height, one that could contain a myriad of viewpoints, and recompose the infinite facets into a pictorial whole in order to find a total relationship between space and form. They opened up the pictorial plane to the infinite possibilities of vision in their attempt to find the truth of the object by means of multiple perspectives. The object was no longer represented according to a single point of view, but was a real solid object analysed in each and every part, from every point of view, and in the infinite relationships that were continually being created between object and object, and object and space. Starting in 1909, the volumes were sectioned and fragmented into infinite plastic planes by the widespread play of light. The surface of the work was decomposed and reduced to thin geometric elements characterised by more or less intense tones of light. The analysis of the forms became more and more elaborate and complex through the intersection of planes that formed an uninterrupted pictorial scheme that cancelled its depth. Colour became truer, a sort of local colour that originated from the continuous relationships and interference that the different colours of reality created amongst themselves. The work had to be "real", no longer a representation of reality, but reality itself, an autonomous structure capable of functioning because of the internal relationships it had created.

Although Picasso and Braque were working closely together at that stage and dealing with the same problems and themes (still lifes, landscapes, etc.), and their works can almost be confused, it is possible, however, to single out the exact characteristics of each one. While the problem of form was constantly present in Picasso, that is how to render it totally and concretely through painting, what characterised Braque's work was colour, a local colour, tonal and atmospheric. In their attempt to give a total view of the object, in which form and space blended into a single element by means of rational analysis, the two artists, because of an excess of analysis during this stage, arrived at a sort of chaotic, almost hermetic, confusion of the vision.

In order to avoid the danger of losing the concrete objectivity of the work, they placed letters and numbers, at first painted and later pasted, on the canvas as if they were masses of colour or elements of the painting in order to return to the concrete form of the thing. They

subsequently pasted fragments that came from the real world onto the canvas, like newspaper clippings, wallpaper imitating marble or wood, corrugated cardboard, pieces of glass or other materials, in a kind of collage that accentuated the picture's capacity of being an "object". Even the shape changed radically and in order to avoid the traditional limits of the frame and the edge, they made use of oval-shaped canvases which contributed to turning the work itself into an object, and widened the limits of painting whose plastic volumes they emphasised by means of the material, thus bringing it close to sculpture.

It was during this stage that the young Spanish painter Juan Gris approached the two artists. In 1911, he joined the Cubist movement and in 1912, began to paint like the two great masters, maintaining, however, his own personal autonomous style. Equally important for Gris was Cézanne's painting, his work on volumes and its reflection on geometric structure. His research was later characterised by strong colours even if they were used in an almost monochromatic tonal scale. Gris's arrival marked the beginning of Synthetic Cubism: in fact he himself declared that "yesterday's analysis has become today's synthesis." For Gris, painting was a "flat and coloured architecture" in which rigorously geometric constructive elements intervened. Picasso and Braque agreed with him that "the truth is beyond any realism and the appearance of things should not be confused with their essence", an essence that was the basis of all Cubist research. The objective was to render the abstract real and for this reason, in contrast to Cézanne, Gris stated: "I can make a bottle from a cylinder."

Many artists were working in the Cubist climate of the 1910s, among whom Fernand Léger, Jacques Villon and Robert Delauney. With Orphic Cubism, a term coined by Apollinaire, Delaunay proposed that painting be based on movement. The decomposition of colour according to the rules of the optic prism contributed to the development of movement in paintings in which "horizontals and verticals" were no longer present and where "light deforms everything, breaks everything up", as the artist himself remarked.

Futurism

Futurism was founded in Milan in 1909 by a group of artists and writers. The theoretical manifesto that they drew up was published in the newspaper *Le Figaro* that same year in Paris since the French capital was then considered to be the art centre of the

world. The theories of the movement were based primarily on a desire to destroy everything stale and out-dated from tradition and the past (museums, libraries, cities of art, etc.) so as to create a new situation based on the myth of the motorcar and velocity. Such dynamism became a conceptual and formal (concrete) instrument capable of introducing contemporary and modern elements into the work: "The magnificence of the world has been enriched by a new beauty, the beauty of velocity. A roaring automobile that seems to run like a machine-gun is more beautiful than the *Winged Victory of Samothrace*," the Futurists announced in their first theoretical manifesto.

Italian art at the beginning of the century was in a rather marginal position with respect to the important researches that were going on throughout Europe, in particular in Paris. In that stagnant and academic atmosphere in which young artists who wanted to keep up with the times had to go to Paris, the birth of an avant-garde movement like Futurism took on the value of an outright declaration of war, a total break with the past and an opening up to new territories of investigation and new languages of art.

Italian Futurism marked the beginning of the great season of the avant-garde artistic movements of the twentieth century. It was an adventure that would witness in just a few years' time the genesis of extraordinary theories and revolutionary works, a rebellion against the principles of the past and also those of the present in order for art to have the value of a real "revolution". The avant-garde, especially that of Futurism, was alert to realism and all its expressions were characterised by strong ideological values that meant to influence not only the language of art but also the social structure.

Italian Futurism was born out of the collaboration between the poet Filippo Tommaso Marinetti and the artists Giacomo Balla, Umberto Boccioni, Carlo Carrà, and Luigi Russolo, with Gino Severini and Enrico Prampolini joining the movement later, and for a short time Ardengo Soffici. Its "birth certificate", the *Manifesto del Futurismo*, was published in February 1909 in *Le Figaro* in Paris. The proclamation was written in a rather violent, outspoken language in which every declaration was radical, absolute and definitive. Marinetti and his companions declared their position regarding art, culture and society in the eleven points of the programme. They spurned the past without exceptions, and yearned for a future characterised by new propulsive forces like the automobile and speed; they declared the

absolute negativity of history whose values and "monuments" had to be destroyed in order to give life to new forms for the future. By asserting that "the magnificence of the world has been enriched by a new beauty, the beauty of velocity. A roaring automobile that seems to run like a machine-gun is more beautiful than the *Winged Victory of Samothrace*," they wished to underline their total adhesion to the new discoveries of the modern world, which were connected to the machine as a mechanism that produces but also, like the automobile, generates speed by itself.

It is for this reason that in their works, whether they were painting or sculpture, poetry or literature, music or dance, photography or theatre, architecture or cooking, the dynamic element was omnipresent and absolute. Boccioni, in paintings like *The City that Ascends* (1912) and in sculptures like *Unique Forms of Continuity in Space* (1913), but also Balla and Carrà, created a dynamic synthesis that was in contrast with the static Analytic Cubism which they opposed. Futurism set the theoretic and analytic Cubist machine into motion. Dynamism, for the Futurists, was speed involving two elements: the object in movement and the space in which the object moved. In their works, for example in Boccioni's *Unique Forms*, it is clear how body and space constitute one single structure in which the two elements, body and space, are moving in opposite directions but with the same intensity, thus creating movement. Both the body and the space are in motion and between them create an attrition in which the body, in Boccioni's case the human body, is deformed in its soft parts while the supporting axes of the corporeal mass remain firm according to the "lines of force" provided by the bone structure. Boccioni created a new aerodynamic figure, one that anticipated the studies of dynamic morphology that are still fundamental today.

The dynamic and aerodynamic aspect was also central to Carrà's and Balla's work, and it resulted in a dynamism underscored by the use of colour that was ready to emphasise the propulsive forces of the forms and a construction composed of broken, angular, rapid lines. With Carrà the work became a turmoil in which the emotional aspect of the representation was stressed, as in *The Funeral of the Anarchist Galli* (1911) in which a turbine of forms, colours, noises and sensations seemed to bring the observer directly into the painting, dragging him into the centre of the event and the centre of the painting. The broken lines, the agitated and frenetic rhythm, the two predominant colours, red and black, that underscored the drama of the event all the more, created a vertigo of forms and emotions towards

Henri Matisse,
Interior at Collioure,
1905. Private
Collection, Zurich.

Henri Matisse,
Study for *The Joy
of Life*, 1905.
Statens Museum
for Kunst,
Copenhagen.

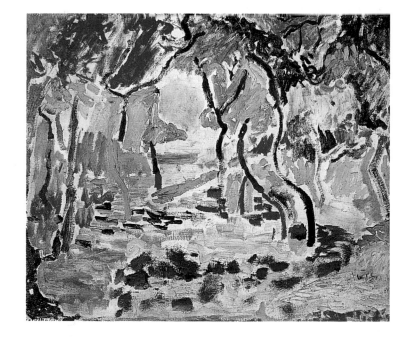

I

Ernst Ludwig
Kirchner, *Five
Women in the
Street*, 1923.
Wallraf-Richartz-
Museum, Cologne.

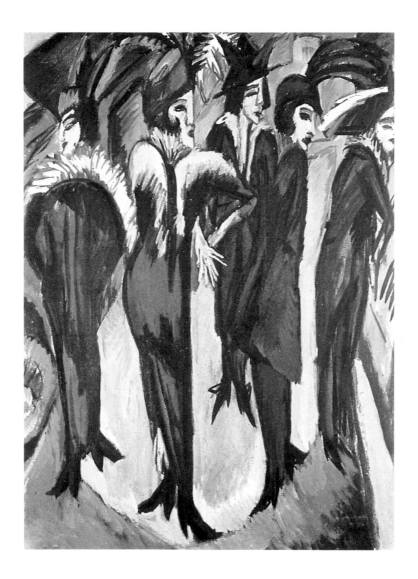

Pablo Picasso,
*Les Demoiselles
d'Avignon*, 1907.
The Museum
of Modern Art, New
York.

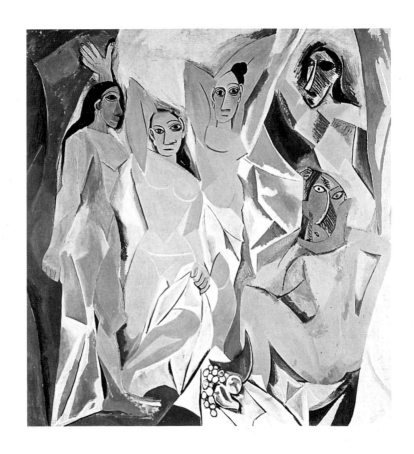

Pablo Picasso,
*Bread and Fruit
Dish*, 1908.
Kunstmuseum,
Basel.

Georges Braque,
The Table, 1911,
Musée National
d'Art Moderne,
Centre Georges
Pompidou, Paris.

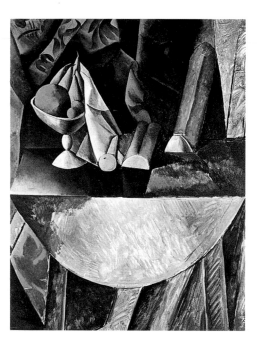

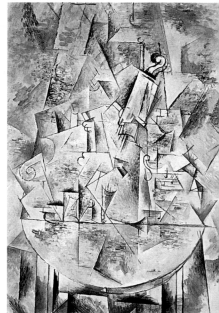

Juan Gris, *Grey
Still Life*, 1912.
Rijksmuseum
Kröller-Müller,
Otterlo.

Pablo Picasso,
*Portrait of
Ambroise Vollard*,
1909-1910, Pushkin
Museum, Moscow.

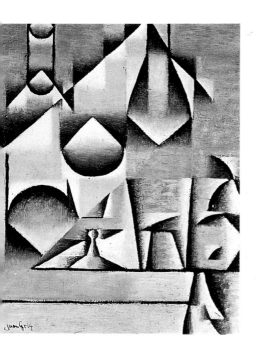

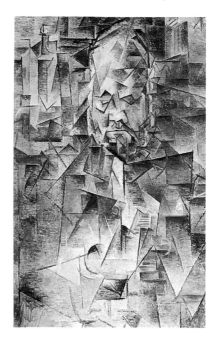

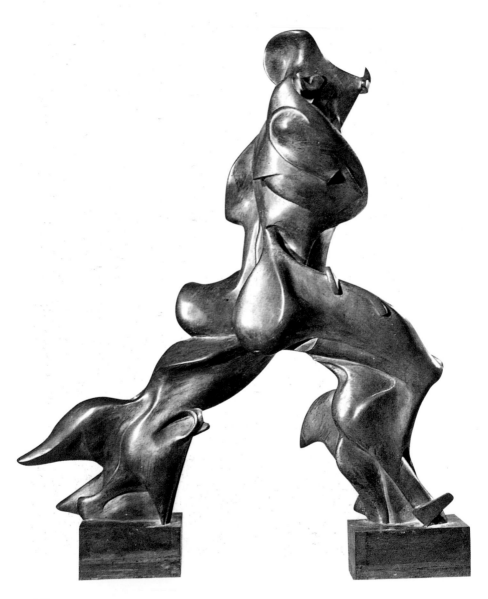

Umberto Boccioni,
*Uniform forms
of Continuity in
Space,* 1913. Civico
Museo d'Arte
Contemporanea,
Milan.

Carlo Carrà,
*The Funeral of the
Anarchist Galli*,
1911. The Museum
of Modern Art, New
York.

Giacomo Balla,
*Plasticity of Lights +
Velocity*, 1912-1913.
Slifka Collection,
New York.

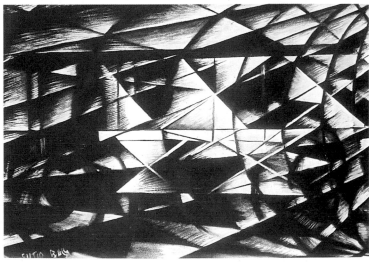

Wassily Kandinsky,
The Blue Rider,
1903. Bührle
Collection, Zurich.

Franz Marc, *Three Red Horses*, 1911. Private collection. Rome.

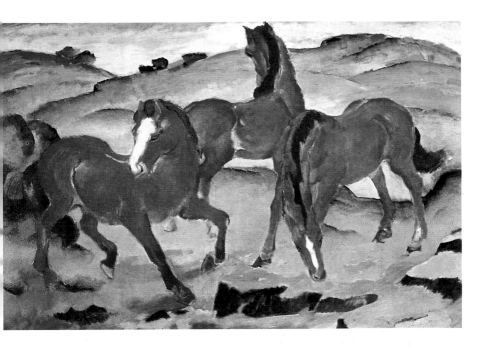

Wassily Kandinsky,
*First Abstract
Watercolour*, 1910.
Musée National
d'Art Moderne,
Centre Georges
Pompidou, Paris.

Paul Klee, *Main
Street and Side
Streets*, 1929.
Wallraf-Richartz-
Museum, Cologne.

Piet Mondrian,
Picture I, 1921.
Müller-Windmann
Collection, Basel.

Wassily Kandinsky,
Points in the Bow,
1927. Private
collection, Paris.

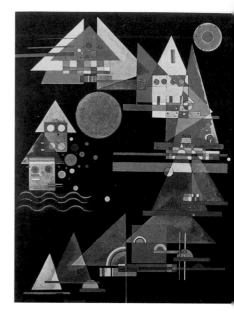

Kazimir Malevich,
*Suprematist
Composition*, 1915.
Regional Museum
of Art, Tula.

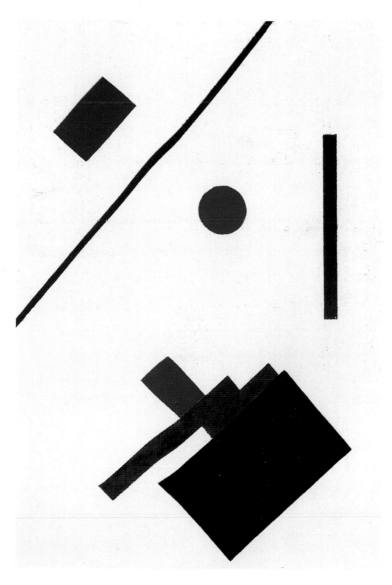

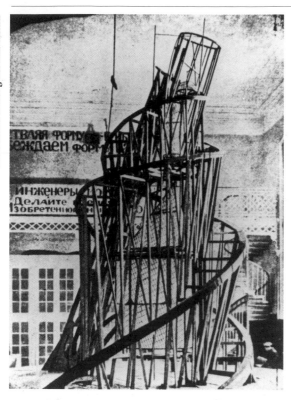

Vladimir Tatlin, *Monument to the Third International*, 1919. Russian National Museum, St. Petersburg.

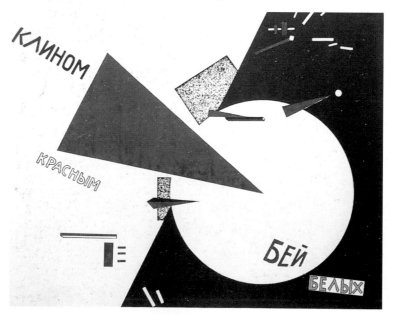

El Lissitsky, *Beat the Whites with the Red Wedge*, 1919-1920. Stedelijk Van Abbemuseum, Eindhoven.

Giorgio de Chirico,
*Hector and
Andromache*, 1917.
Private collection,
Milan.

Carlo Carrà,
*The Drunk
Gentleman*, 1916.
Private collection.

which it was impossible to remain indifferent.

Although Balla's Futurist painting was initially more figurative, he also became more abstract as in *Plasticity of Lights + Velocity* of 1912-1913, which did not represent the body-machine in movement as much as it did velocity, the very idea of velocity. In fact, the faster a body moved in space the more abstract was one's perception of it. The colours, in this case, were black and white: black wedges chasing one another in a wake of white light; what was perceived was the motion of the machine and not the object, its pure speed. Balla also used colour to emphasise dynamism: the pictorial material was no longer used according to a naturalistic logic or a symbolic value, but rather as chromatic simultaneity, as occurs in the iris of the eye where colours are present at the same time and express a law of harmony and fusion, while maintaining firm the principle of velocity.

But dynamic forces were also present in architectural research as can be seen in Antonio Sant'Elia's designs for buildings and cities. In his project, the *New City*, 1914, as in the *Manifesto of Futurist Architecture*, his architecture displayed a dynamic upward thrust, and was aimed at a totally new idea of a building and of a city.

The Futurists analysed and experimented a wide range of languages and techniques which also produced important results in music, thanks to Russolo and his "intonarumori" (intoned noises), and poetry with Marinetti's "parolibere" (free words) which were dynamic poetic tables in which the text became a graphic structure where the signifier and the significant coincided, and in photography with Anton Giulio Bragaglia's "photo-dynamics."

The Futurist experience ended with the outbreak of the First World War and the deaths of Boccioni and Sant'Elia. Immediately after the war, a new wave followed: the second Futurism. Its promoters were Balla, Fortunato Depero and Marinetti. Unlike the first, this second Futurism was marked by a reduction of the dynamic element in favour of greater decorativeness. Many other artists adhered to this second movement in addition to the ones already mentioned, among whom, Enrico Prampolini, Primo Conti, Gerardo Dottori, Tullio Crali, Fillia, Giulio Evola, and Farfa.

Der Blaue Reiter

Wassily Kandinsky and Franz Marc founded this movement in Munich in 1911. Criticising Cubism which they considered too rational, and German Expressionism because of its strong social

content, the two artists wished to revive the primitive, naive painting of Rousseau 'le Douanier' in order to create a pictorial language that expressed more intimate feelings. In contrast with the objectivity of Cubism and the social problems of Expressionism, their painting was based on a totally formal equilibrium, the transparency of colour and a harmony of forms of almost Oriental derivation.

Der Blaue Reiter (The Blue Rider) movement, from the title of a painting by Wassily Kandinsky of 1903 depicting a blue-cloaked rider galloping across a green field, started in Munich in 1911, the year of the group's first exhibition, while their document-book (*Blue Rider Almanac*) was published the following year. With regard to the choice of the name, the Russian artist recalled: "We both liked blue, Marc liked horses, and I riders, and so the name came by itself."
More than anything else, the two painters wished to investigate the spiritual and empathic quality of art. Starting from Expressionist research, they accentuated the spiritual characteristics inherent in painting, but abolished the political and social commitment that had distinguished the German Expressionist movement, Die Brücke. According to them, art had to become autonomous with respect to the world, and develop a language of its own to represent the victory of Oriental irrationalism over Western rationalism. They therefore explored Oriental cultures in the same way as they did fables and the iconography of Nordic folklore, as ideal places or elements to use in their research where the intrinsic semantic value of form and colour assumed primary importance.
They presented Rousseau's works next to their own in their first exhibition and in the *Almanac*, for they felt his research was fundamental because of what it had been able to eliminate from painting. Rousseau's "zero degree", Japanese culture, and the work of Robert Delaunay (the only living French artist they had accepted up until then, his work being considered fundamental because of his criticism of the Cartesian rationalism present in Cubism in its analytical stage and his concept of colour-light dynamism), were all elements that were necessary for understanding the aesthetics of the Munich group.
The spirituality that Kandinsky and Marc sought was not an ideal or a symbol but rather a non-rational given that corresponded to an existence in which physical reality and psychic reality were closely tied. Therefore, form and colour did not exist before the act of painting,

but were its result and thus closely connected to the gesture that generated them.

The presence in the group of both figurative and abstract painters was an indication that the basic problem lay in the artist's ability to search for a spiritual and empathic balance with the inner world, as well as the world of phenomena and things, and was unrelated to the naturalism of forms or their reduction to an abstract concept. The works of Marc and August Macke, another member of the group, were decidedly figurative, but they were not limited to a pure representation of the external world. Marc emphasised his search for man in his original state, in his lost naturalness, through a harmonious representation of animals and a passion for the Orient, while Macke chose to express the purely visible in his paintings as an end in itself. Equal to Kandinsky in theory and practice was the Swiss Paul Klee, whose research lay in the same direction. These two painters were united by the same principle. For them, the world of meanings was much vaster than the rational and objective world, and the aesthetic communication that originated from it had to be as immediate as possible, a communication that went from man to man without any mediation. Art was an inter-subjective aesthetic operation, one that could take on a didactic and formative function. The artistic operation was conceived as research capable of rendering visible what was concealed to the majority, and it therefore became an instrument for investigating a spirituality that only the practice of art and the work of art deriving from it could reach and make visible

Abstract Art

Starting in the 1910s this term was used to describe a cultural climate that had developed in Northern Europe primarily. The artists and theorists who were involved in abstract art were interested in defining a new language in the arts, one that was no longer tied to a figurative and realistic representation of the world, one adopting only pure formal elements (line, colour, surface) that were utilised for their own intrinsic qualities. Abstract art provided inspiration for numerous artists starting with Kandinsky, and many movements like De Stijl (The Style) which was founded in Holland in 1917, and the Bauhaus (Building the House) founded in Germany in 1919.

In 1908, the theorist Wilhelm Worringer, in his essay *Abstraction and Empathy*, opened the way to research into the abstract which would

prove decisive for the art of the twentieth century for it became, together with figurative art, the second pole of pictorial language. Abstraction was quickly adopted by some artists, in particular Wassily Kandinsky who painted his *First Abstract Watercolour* in 1910, and then by Paul Klee, Piet Mondrian and many others who, united in groups like De Stijl in Holland and the Bauhaus in Germany, or singly, adhered to the principles of abstraction that Worringer had set forth, and which Kandinsky had picked up in part in his books *Concerning the Spiritual in Art* and *Point and Line to Plane*, as well as in his pictorial works.

Also important for the theorisation of abstraction were some of the insights that had been made during those years in disciplines other than painting, like music and psychology, especially the psychology of form and colour, in order to define a spirituality in the work of art that could be expressed by means of form and pure colours, and free from any reference to a representational or figurative character. From the time of his first abstract work, Kandinsky was already seeking, through forms and a childlike almost doodled scrawl which eliminated all language, some "other" significance so as to obtain pure forms and colour whose only reference was to themselves.

The task of abstract painting was to express, through its own materials, a primary state of consciousness that had no ties at all with the conventional language of representation. The plan of the work became a plan of total freedom of expression where the artist could manifest his own inner nature, feeling and spirituality, without being subject to any preordained representation. At this stage, the artist was like a child who constructs his own map of forms and colours and sends them to the modern man who must read them like art, like a pure aesthetic experience.

During the 1910s, Kandinsky painted his *Improvisations* in which form was presented in its nascent state and therefore free, while in the following decade, when he joined the group of teachers at the Bauhaus (the school of design founded by Walter Gropius at Weimar where Klee, Albers, Moholy-Nagy, Itten, Schlemmer and Feininger also taught), he seemed to feel the need to create order in a pictorial structure that was filled with elements that were subject to no rules other than those of sensation. At the Bauhaus, the artist therefore organised the emerging elements according to a more rational, codified language, one that was geometric and in harmony with the principles of the school; that is, a totally rational rigor was applied to a methodology of design that combined practicality and aesthetics.

Design at the Bauhaus followed a rational-abstract order in which the need to unite art and industry was stressed. Objects, architecture, graphics and theatrical representations came to life inside a rigorous scheme in which the forms operated in a flat or three-dimensional space so as to emphasise both their practical and aesthetic elements. The democratic and utopian project of the Bauhaus was undoubtedly unique and unrepeatable in its use of abstract artistic language in order to arrive at a production in which aesthetic and practical values participated in the same adventure. In Holland in 1917, the magazine *De Stijl* was published, founded by Theo van Doesburg together with Piet Mondrian, which gave rise to the movement that took the name of Neo-Plasticism.

Neo-Plasticism was immediately recognised as being an avant-garde movement which, because it dealt with architectural problems in particular (Holland in those years being one of the most advanced European countries as far as architecture was concerned), attempted to make use of abstract art by declaring that art and life were bound as absolutely as aesthetics and design. To this effect, Mondrian wrote: "We must understand that art and life are not separate domains. This is why the idea of art as an illusion that is separate from real life must disappear." Therefore, the problem for De Stijl, as for the Bauhaus, was that of applying abstract language to research that involved architecture and painting, the applied arts, and design.

The collaboration between Mondrian and van Doesburg was established only after a long period of controversy since Mondrian did not immediately accept the idea of his pictorial structures being applied to architecture for he maintained that his pictorial language was a plastic representation that was resolved in itself. Only later did he accept the theories of De Stijl, asserting that "the adventure of the new plasticity and its most suitable realisation are to be found in the chromo-plasticity of architecture."

For De Stijl, design was a theoretical act above all which did not necessarily have to consider problems of practicality and function, whereas for the Bauhaus, design was the result of the union between the theoretic-aesthetic element and the functional-practical one.

Abstraction subsequently spread throughout all of Europe. In Paris, the groups Cercle et Carré (Circle and Square) and Abstraction-Création were founded, and later, in 1946, Réalités Nouvelles. In Italy, in Milan and Como primarily, research into abstraction developed throughout the 1920s, 1930s and 1940s at Gino Ghiringhelli's Galleria del Milione. The Italians were closer in a certain sense to the

Parisian group of Cercle et Carré which had been founded in 1930-1931 by Joaquín Torres García and by the critic Michel Seuphor, with whom Atanasio Soldati was in contact, and to the Abstraction-Création group, established in 1933 by Auguste Herbin, Ben Nicholson and Mondrian among others. In addition to Soldati, the other Italian artists who appeared on the scene during that period were Lucio Fontana, Osvaldo Licini, Fausto Melotti, Alberto Magnelli, Luigi Veronesi, Aldo Reggiani as well as the so-called "Como group" which included Mario Radice, Manlio Rho, Aldo Galli and Carla Badiali. The Italian abstractionists' research, directed primarily at formal problems in which the pure geometry of form and chromatic refinement were united to an absolutely theoretic rigour, earned their works international recognition.

Later, in 1948, Gillo Dorfles, Gianni Monnet, Bruno Munari and Atanasio Soldati founded the MAC (Movement of Concrete Art) in Milan, to which many Italian artists adhered. Its objective was to propose itself as "concrete art" in contrast to false abstraction, and it continued the abstract-concrete researches of such historical fathers as van Doesburg, Mondrian, Arp, and Max Bill in order to develop a new formal purity and an international aesthetic language.

The Russian Avant-garde Movements

Between 1910 and 1920 the widespread cultural and artistic unrest in Russia gave rise to three important avant-garde movements: Rayonism, Suprematism and Constructivism. Rayonism, founded by Mikhail Larionov and Natalja Goncharova, and influenced by Italian Futurism, reinvented the pictorial plane as a field of light in movement. Malevich's Suprematism took its start from his painting *Black Square on a White Ground* of 1913 in which the artist eliminated representation in order to favour pure sensation in painting. The Constructivism of Tatlin, El Lissitsky and Rodchenko sought, through the structure of the work, an identity between artistic beauty and political justness.

Russia joined the rest of the world artistically through the avant-garde researches of Rayonism, Suprematism and Constructivism, as well as its European contacts with the Parisian world of art, and such outstanding figures as the poet Vladimir Majakovski and the artists Kandinsky, Malevich, Gabo, Pevsner, Tatlin and Chagall.

30

In the first decades of the century, the country experienced a strong modernist impulse in which the intellectuals opposed the anachronistic regime of the Tsars which was so determined to remain in power. That tension and contacts with the European art world, in particular with the Futurists, resulted in the Rayonism of Mikhail Larionov and Natalja Goncharova. In their manifesto, the two declared that Rayonism was a "synthesis of Cubism, Futurism and Orphism." In their paintings, space was filled with beams of light in movement which crossed the surface of the canvas with interfering rhythms and decomposed according to the laws of the optic prism. Larionov's Rayonism explored Orphic-luminist lines, while that of Goncharova was closer to that of the Futurists in which the dynamism of the machine, like a pulsating mechanism, synthesised the body and space in velocity.

Kazimir Malevich's research was along different lines (he was later joined by Nikolaj Suetin, Ilja Chashnik and Anna Leporskaja) for he started from a study of Cézanne and Picasso and went on to explore the functional structure of the image. After his Cubo-Futuristic experience, Malevich arrived at Suprematism in 1913. Together with Majakovskij, he drew up its *Manifesto* in which they declared the need to find a correspondence between idea and perception: everything took shape in the definition of a pictorial space that was meant to be a geometric symbol, an absolute abstraction. Malevich wrote in the *Manifesto*: "For Suprematism I intend the supremacy of pure sensation in the figurative arts," indicating by that statement the absolute necessity on the part of painting to express its own spiritual autonomy and sensitivity with respect to reality. Painting for Malevich was therefore pure sensation, an autonomous aesthetic fact free from any premise of representation. The painting was an instrument that was able to communicate a state of total balance and identity between subject and object.

What the artist theorised and achieved was the conception of a pictorial reality devoid of objects, phenomenal data, and temporal notions in which the object and subject were reduced to the "zero degree", that is, pure painting. In *Black Square on a White Ground*, Malevich focalised on such elements: the black square on the white ground was meant to show that art no longer needed external reality in order to exist, it was reality itself being "full of a spirit of non-objective sensation".

From that moment on, the artist began to use a more precarious geometry to create a formal and pictorial world that was emancipat-

ed from any finality or concrete necessity. It was on this terrain that he came into contrast with the Constructivism of Vladimir Tatlin, whose work had a revolutionary finality. When Tatlin approached Malevich for his collaboration, the latter refused to have anything to do with matters of a political or social nature. Although he understood and sympathised with the Bolshevik revolution of 1917, the Suprematist artist took refuge more and more in his own work, painting in 1918 his *White Square on a White Ground* which carried his theory to the utmost extreme.

The Constructivism of Tatlin, El Lissitsky and Aleksandr Rodchenko took root and grew out of the issues and facts of the October Revolution as did the movement's aesthetic and ideological theories. By questioning art's function in a revolutionary context, the Constructivist artists regarded their own work as a basic instrument for the success of the revolution itself and, although they were close to Malevich's abstract language, they declared that it was absolutely necessary for art to be useful to society. While maintaining its own linguistic autonomy, art had to assume a social role in order to communicate the revolutionary values to the people; it could no longer be narration but rather the visualisation of revolutionary concepts with the declared finality of becoming a form of communication and thus contribute to the formation of a new state. The *Monument to the Third International* by Tatlin (1919), which remained at its three-dimensional model stage, was an enormous tilted asymmetric spiral that was meant to be fabricated in metal and contain glass units to be used as meeting places for the Supreme Soviet, its precise public function being that of a dynamic element for the transmission of information to the outside world. With this work, Tatlin wished to demonstrate that art not only had to work on its own self and its own language but also serve as an instrument for the construction of a concrete reality.

This also occurred in the works of Rodchenko and El Lissitsky, especially in the latter's poster, *Beat the Whites with the Red Wedge* (1919-1920), where, in an abstract geometric structure whose colours were reduced to a white ground and red and black forms, it was clear that the artist's intent was to communicate the victory of the revolution. His *Prouns,* designs of new forms in a variedly articulated space, although of no immediate practical function and very similar to Malevich's solutions, had a different use, however, that of creating goals, goals that concerned the birth of the new society.

Metaphysical Painting

Taken literally, the word "metaphysics" means that which tran-
scends physical reality. It was adopted by Giorgio de Chirico in
1910 when he reacted against the Futurist uproar by painting its
exact opposite, the metaphysical, counteracting the dynamism
and din of Futurism with immobility and silence. An Italian piaz-
za or a mannequin, typical metaphysical subjects, thus became
instruments for a figuration devoid of any immediate reference to
real things like places or definite times.
What the metaphysical artists were questioning were the histori-
cal concepts of time and space through images that evoked
places and times belonging more to the imaginary than to the re-
al, and more to the universality of culture than to the partiality of
the quotidian.

Immediately after the Futurist uproar, Italian art seemed to fall back
into a kind of provincialism with respect to the rest of Europe al-
though it continued to seek an originality and autonomy of its own.
A remarkable stimulus for renewal was made by the artist, Giorgio de
Chirico, whose formation was international and who was trying to
revive some of the Italian figurative tradition, enriching it with new
values. This resulted in Metaphysical Painting which, unlike Futur-
ism, sought a pictorial language that went above and beyond histo-
ry, an art that could pass over the real time and place of its genesis.
In the works of the *pictor optimus*, as he liked to call himself, there
was a return to Classicism, not the rational classicism of the Greek
world of ideas, but rather an absolute classicism that was detached
from time and history. For De Chirico, art was not to have any rela-
tionship to its own contemporaneity, it was not to participate in the
major and minor historical events, nor was it to be an ideological in-
strument or confirm social values. It was to be, using the prefix *meta*
of Greek origin meaning "after", *meta*-reality, *meta*-history, *meta*-
physics.
In the works of De Chirico like *Hector and Andromache* or the *Ital-
ian Piazzas*, as well as in those of Carlo Carrà (who left Futurism in
1915 to join Metaphysical Painting), there was a suspension of all the
fundamental values of Western culture, primarily through the elimi-
nation of the space-time categories. New definitions of space and
time were favoured, ones that appeared alienating, immobile, absent
and eternal. Their works, disquieting and enigmatic, posed continu-

33

ous questions for which no answers or solutions were provided. The enigmas of the metaphysical works created anguish and alarm because the observer was placed in front of a pictorial reality that had no relationship with the phenomenology of things, and which remained ambiguous even when deciphered. Originating from a position of superiority with respect to the present and past, the enigmas proposed a possible metaphysical solution where everything was immobile, still, lifeless, where space, like things, and time, like the atmosphere, offered no response because no response was possible.

The figurative elements utilised, mannequins, geometric and technical drawing instruments, Italian piazzas, puffing but unmoving trains, the mysterious shadows of invisible figures or unplayable games; all of these, placed in apparently nonsensical relationships, took painting back to its intimate meaning, to a searching that occurred within the work of art to which the work responded.

Art did not serve the world; it was not its illustration or representation; it went beyond those functions. Its only objective was the investigation of its own language, its own structure; it was the search for an image that, because it had nothing to do with reality, referred only to itself and its own identity. De Chirico himself underlined the need to clear away all those elements that were already known, declaring that "what is primarily needed is to rid art of all it has contained up to today." In his paintings, spectres and relics, both ancient and modern, inhabit a kind of archaeology, and take shape in a tense, disquieting landscape, one that is so "true" as to be metaphysical.

The same thing occurred in the works of Giorgio Morandi who adopted the more concrete, solid and present element of Metaphysical Painting. While painting was another kind of space for De Chirico, and for Carrà it was the act of becoming geometry, for Morandi it was the concreteness of the thing, and the work of art was the place where object and space assumed equal importance in a continual play of formal and chromatic equilibrium. Alberto Savinio, on the other hand, was more interested in problems related to the theoretical language of the work than in its formal plan. For him, the metaphysical component was an intellectual rather than a practical operation.

Apart from the differences between the individual artists, there was in the themes, the unrest and enigmas of all the metaphysical works, and in part even in the theoretical solutions, a prefiguration almost of the Surrealist movement that would scandalise bourgeois society some ten years later by questioning its false beliefs and revealing its most hidden secrets and inclinations.

34

Dada

In 1916, during the middle of the war in neutral Zurich, a hetero-
geneous group of artists and intellectuals founded the Dada
movement. That term, of controversial origin, described an event
in which entertainment, pure chance, and total liberty were the
decisive elements for making art. The movement was highly crit-
ical of the forms of art and the society of the times. Hugo Ball,
writer and philosopher, Tristan Tzara, poet, Richard Huelsenbeck,
poet and doctor, Hans Arp and Marcel Janco, painters, where the
theorists and founders of the group.
Dada was the negation of everything, it was the accidental and
the rule, the freedom of the game, and an attempt to give some
kind of order to the chaos in the world; it was art and the nega-
tion of art. Dada endeavoured to get out of the narrow confines
of painting, sculpture and poetry so as to open these up to the in-
finite aesthetic possibilities offered by the materials and events of
daily life.

Dada started in Zurich in 1916 at the Cabaret Voltaire during the
First World War. Unlike the other avant-garde movements that had
preceded it and criticised art and society in order to change them, the
Zurich movement's protest was against all the artistic and social val-
ues of the times, since it rejected the idea that a work of art become
part of a commercial operation.
The term "dada" seems to have been discovered by chance in a dic-
tionary, but its meaning and origin are uncertain and controversial.
For some it refers to the language of children, for others to an inter-
calation in speech, for still others to a variety of other things. Zurich
was not the only place where Dada developed; two other important
centres of the movement were in New York and in Berlin.
After the 1913 Armory Show in New York, which was dedicated to
American avant-garde art, Marcel Duchamp, Francis Picabia and the
photographer Alfred Stieglitz, and Man Ray soon after, published the
review *291*, in which they announced that their research was along
the lines of the Zurich movement. Dada spread rapidly throughout
the world and many were the artists who adopted its modalities as
their language.
It was not at all accidental that the movement started and developed
during the war, and in two places in particular, Switzerland and the
United States, for both were less involved in the world conflict. The

war had produced a crisis in all Western values as well as in its rational structure, productive capacity, culture, and therefore also in its art. For the Dadaists, art was not supposed to produce value, on the contrary, it had to negate value as nonsense that was in contrast with the creation of the work of art as it had been conceived up to that time. "Artwork of value" had no sense for the Dadaists. If art was a pure and aesthetic fact, then it could not have anything to do with the modern production of objects of value (works of art), and had to be emancipated from any commercial value. Art, pure positive nonsense, had the task of opposing the negative nonsense of reality which, driven by "rational" logic, had led to the crisis, to the destruction of all ideals, and to the war.

But the accidental was also nonsense, as was the game; they had an inner logic of their own which endowed art with instruments that enabled it to oppose the negativity of the world. On a formal plane, the Dadaists criticised the rationality and excessive formalism of Cubism in particular, especially during its analytic period. Duchamp was the most outspoken in his criticism in *The Bride Stripped Bare by her Bachelors, Even* (1915-1923), a work that was neither a painting nor an object, but rather a construction made up of images painted on glass, a machine with a purely symbolic function, one that questioned the very idea of the functionality of the Cubist work.

The Dadaism of Zurich was characterised primarily by a variety of deliberately rowdy performances that were meant to scandalise and outrage in which the artists showed that it was impossible for art to have any relationship whatsoever with the perverse logic of reality. Because of this, Dada was to be understood as a negative avant-garde movement, one that had no interest in impressing the world with the production of "works of value". The quality of chance that distinguished the movement led the artists in the direction of anti-art, anti-value, anti-technique, anti-art work. Dada was a continual negation.

From a technical and formal point of view, the Dadists' experiments were bold and conceptual. They ranged from the ready-mades of Duchamp, found objects used as they were or assembled together, like *Bicycle Wheel*, 1913, and the *Fountain*, 1917, to the works of Picabia in which improbable mechanisms underlined the current crisis of functional thought by means of their own non-functionality. Similar in concept were Man Ray's "rayogrammes". These were images obtained photographically and purely accidentally, black and white negative images that showed the traces of objects that the artist had casually placed on the emulsion surface. The three-dimensional,

"amorphous" works of Hans Arp were not meant to represent anything; they were simply a gesture against the organised, rational functionality of reality that turned everything into an object.

Kurt Schwitters, on the other hand, assembled objects, pieces of paper or cloth, and placed them haphazardly on the canvas or in three-dimensional structures. His monumental work, *Merzbau*, was executed in his house in Hanover between 1923 and 1932 where he amassed an enormous quantity of diverse materials inside and outside the house in order to "construct a *merz*" as the title of the work itself indicated. Schwitters was a member of the German Dadaist group, founded in 1917 in Berlin by Huelsenbeck, whose other members included George Grosz, Hannah Höch and Max Ernst.

Whether they were two—or three—dimensional, the Dadist works did have one common denominator: they were a criticism of the artistic product, even that of the avant-garde, which had up until then followed more or less traditional schemes.

Dada did not criticise the order of the work, but rather the order underpinning the abstract schemes, inasmuch as the Dadaists intended a work of art to be a pure aesthetic act that involved existence itself. It was a way to give life back to the increasingly uncontrollable heap of materials that modern society had accumulated and thrown away. The work of art contained an array of objects that had past experiences, and from that array, from that accidental mingling of forms and signs from different experiences, the work of art was created. It was similar to an organism that lived and developed by taking strength and energy from what happened to it, and from whomever it came into contact. No theory of the world brought it about, but within the theory or anti-theory of art, the work participated in the flux of events that enriched it from time to time.

Surrealism

In 1924, André Breton published the *Surrealist Manifesto.* The movement, adhered to by artists and intellectuals from a variety of backgrounds, immediately created a language of rupture. Its research was centred chiefly on an investigation of the hidden places of the ego. Drawing inspiration from Freud's psychoanalytical theories, Surrealism tried to transform to the canvas or into sculpture, as it did with poetry, literature and in the cinema, that which disturbed man who through his unconscious released his own secret desires and inclinations. The Surrealists, however,

declared that the work of art did not spring from memory or the interpretation of dreams, but was itself a dream, the creation of a dream through the materials of art.

After a brief experience in the Dada movement, whose legacy he inherited in part, André Breton founded Surrealism in 1924, and drew up the manifesto that he published the same year in the magazine *Littérature*. This movement is also to be included among the avant-garde tendencies inasmuch as its analysis was directed not only at the artistic manifestation but also at the political and social context behind it, with the specific intent to criticise, undermine and scandalise. In his manifesto, Breton defined Surrealism as "pure psychic automatism, by which it is intended to express, whether verbally or in writing, or in any other way, the real process of thought. The dictation of thought, free from the exercise of reason, and every aesthetic and moral preoccupation."

Poet and writer, psychiatrist and expert in Freudian theories, Breton absorbed psychoanalysis into his own aesthetic theories, intuiting how new territories could be opened for art through them. The unconscious was, according to the Surrealists, the true dimension of existence. Art had to have access to it, and share its capacity to express itself through imagery, as occurs in a dream, which is one of the manifestations by which the unconscious makes itself known. It was from oneiric imagery that the Surrealist artists drew their repertoire, however not to interpret it, but rather to revive it aesthetically by creating their own works in a psychic state similar to that of dreaming. Instead of interpreting dreams, art had to come into being at the very moment the dream occurred, in complete tension with the experienced rather than with the represented.

From a technical aspect, Surrealism was close to the open-mindedness of Dadaism. It made use of all the materials at its disposition, from photography to painting, and from collage to cinematography, producing "symbolically functional" objects that were emancipated from any logical use and distorted with respect to their normal appearance. In film-making, the Spanish director Luis Buñuel made further contributions to Surrealism, in particular with two films made during the 1920s and 1930s, *Un chien andalou* and *L'âge d'or*.

At a certain point, a break occurred in Surrealism between words and things, between the signified and their respective signifiers, when the traditional processes came to be questioned.

A former Dadaist, Max Ernst, delved into the concept of psychic au-

tomatism that Breton had theorised, and introduced the technique of frottage. He carried the criticism of the work of art in terms of representation, style and technique to the utmost extreme. By means of psychic automatism it was possible to give life to a set of signs and words that were freely associated but without any preordained logical ties, and which were left to flow freely by the mechanical gesture of the hand. Frottage was also the result of a gesture that did not originate from reasoning or from analytical or logical thought, for it was produced by the purely mechanical gesture of a hand that made precise marks, but not those determined by the artist or by his technical ability, when it rubbed a soft pencil on paper placed on a rough surface. Automatism and frottage, both of which were mechanical and dynamic, opened up therefore to the infinite spaces to the imagination. The Surrealist artists, among whom Joan Miró, Yves Tanguy, André Masson, René Magritte, Salvador Dalí, Hans Arp, Man Ray, and Paul Delvaux, produced works that were formally very different from one another while fully adhering to the polymorphic spirit of the movement, rejecting any previous stylistic, cultural or technical conventions, and following their own instincts, sensations and craft in total freedom. These ranged from the limpid pictorial intellectualism of Magritte which created atmospheres filled with mystery, enigmas and linguistic nonsense, a continual confirmation of the fracture between the signifier and the significant, to the more ingenuous and playful art of Miró who returned to an infantile, oneiric world between dream and irony, one reminiscent of a perverse childhood as in *Harlequin Carnival*, 1924-1925, in which a battle seems to be underway in a room filled with fantastic forms.

In *The Veiling of the Bride*, 1939-1940, Max Ernst depicted that event with a contradictory multiplicity of co-existing faces in a pictorial composition that opposed the primary instincts of eros and thantos implied therein which determined the subject. The painting perturbs and disturbs, it is almost horrifying in its absolute monstrosity, in its lugubrious and funereal vision. The bride is aflame and charged with eroticism as she reckons with the notion of death enveloping her, where the dreamt, and therefore the desired, is both seductive and horrible, and totally ambiguous.

Erotic themes and perturbing visions of the female occur frequently in Surrealist works. Woman is seen as an invincible and perverse object who encumbers and dominates man completely with her secret seductive force. Eroticism, perversion, power, religion, almost all of the declared principles of the current bourgeois culture were ren-

dered explicit in the Surrealist works in order to reveal them and scandalise bourgeois society.

The Surrealist adventure did not die out with the outbreak of the Second World War. It was picked up during the 1940s and 1950s both in Europe and America in different ways by the younger generation of artists who made use of its diverse aspects in their own search for new fields of action thanks to the breakthroughs the movement had succeeded in accomplishing.

École de Paris

After the First World War, many artists arrived in the cosmopolitan and bohemian city of Paris from all over Europe, among whom Utrillo, Soutine, Chagall, Severini, de Pisis, Magnelli, Pascin, and Archipenko, where they constituted the École de Paris. In reality, it was neither a school, nor a specific artistic movement; it was more of an environment or meeting ground where the great masters and the young artists could talk and exchange ideas. All styles and theories were admitted and practised so that art would have that freedom of research that was being silenced by many of the totalitarian regimes in Europe at the time.

Between the two wars, there was an extraordinary cosmopolitan climate in Paris where artists coming from every part of the world converged to meet and talk in order to create a language of art that was neither politically nor stylistically conditioned. The École of Paris was this "climate", this quality of life, a bohemia that accepted all languages. It was an extraordinary warehouse where everything was present, the only condition being that it be modern. And being modern meant being in contact with the most innovative avant-garde European experiences in order to create an art that was free and independent of any political or religious ideology as well as any style or technique.

Unlike some of the other European nations where totalitarian regimes began to take over in the early 1920s, making their presence felt even culturally, France was a free country and it was there that artists converged in order to take part in a dream, the dream of a free and autonomous art. What they were seeking at the École de Paris was an opportunity to work by following their own artistic instincts while adopting the pictorial languages of modernity. Around the

three great masters, Picasso, Matisse and Braque, the young artists felt they were safe as they carried out their research, encouraged as they were to continue in total liberty yet respecting the differences amongst them.

Picasso's painting at that time was marked by a monumental, almost classical formality, though pervaded by a sharp irony. His paintings of perfectly drawn yet exaggerated forms tended towards an idea of the "beautiful" that bordered on the "ugly". In 1937, Picasso painted *Guernica*, a huge composition that represented a reaction against the bombing of that ancient Basque city by the Spanish General Francisco Franco's German allies. What makes the painting a masterpiece, apart from its importance as a political and social document, is its structure which is so similar to an extraordinary classical composition that has been destroyed by the brutality of the very event it describes.

While the Spanish artist had subverted the traditional pictorial language in *Les Demoiselles d'Avignon*, in *Guernica* he attacked the Cubist language and made it explode, creating a work that with only the three colours of black, white and grey declared the death not only of a population that had been bombed, but also of the identity between classical art and modern research. Braque's work, on the other hand, was refined and intellectual. It was centred on rules, theories and norms which, however, did not precede creation but were its result, the condensation of an experience, the synthesis of a long, painstaking work or praxis. Matisse, in turn, showed how art could go beyond the concept of history and be experienced and practised as an aesthetic experience that transcended the mere contingency of the world of things.

Many young artists gathered around the three great masters, Maurice Utrillo, Chaïm Soutine, Marc Chagall, Gino Severini, Filippo de Pisis, Alberto Magnelli, Jules Pascin, Aleksandr Archipenko, Alberto Giacometti, Georges Rouault, Constantin Brancusi, Amedeo Modigliani, and still others who took part in that cultural adventure and returned to their own countries with what they had learned and experienced.

The École de Paris with its libertarian and cosmopolitan spirit, its bohemian artists who gambled their all on genius, with their infinite research and countless works, not all extraordinary perhaps but certainly pervaded with the dream and breath of art, ceased to exist when Hitler's armies occupied France, starting a new war that would upset the entire world.

Realism Between the Two Wars: the Reaction to the Avant-garde

Between the two wars, the totalitarian policies throughout Europe, with the exception of France and its École de Paris, brought about a closure with respect to the avant-garde, and favoured the revival of a figurative art whose roots lay in the different local and national cultures. The pictorial language proposed at the official level was one tied to the figurative representation of reality, although some artists, although opposed and marginalised, continued to practise an art in which avant-garde solutions were still central (the second Futurism, Abstract Art, Surrealism).

During the 1920s, realism became prevalent in painting and was manifested differently according to the diverse schools, formations and cultures.

In Italy, Valori Plastici (Plastic Values), Novecento (1900), Magic Realism, Antinovecento (Anti-1900), and Corrente (Current) tried, by looking to the past and to the origins of Italian art, or by drawing inspiration from the turn-of-the-century European researches, to create a national language based on a revival of the pictorial métier. In the works of the artists who adhered to those movements, reality, which was revived and represented in a variety of ways, was given priority in painting, together with those values that gave the appearance of solidity back to art which the avant-garde had called into question.

In Germany, during the Republic of Weimar and the early years of the Nazi regime, the New Objectivity movement was formed and although its language was figurative, it represented a reaction against the contemporary political situation. Its exponents, Grosz, Dix, Hoch, Beckmann, Schad and Scholz, attempted to depict reality objectively in their works. Their painting thus became an instrument of analysis and bitter social criticism.

In the Soviet Union, once the enthusiasm for the Revolution and the adventure of the avant-garde had waned, a climate of reaction set in. The aim of art was no longer to seek new languages, as the avant-garde had maintained, but to become an instrument of communication and propaganda serving the state. By using a realistic but didactic figurative language that was imposing and celebratory, the Socialist Realism artists extolled political ideology.

Even in Mexico, where a policy of post-revolutionary reconstruction was underway, art was treated as an instrument that could contribute to the re-foundation of a national and political identity. José Clemente Orozco, Diego Rivera, and David Alfaro Siqueiros with their mural cycles (*murales*), revived a popular Mexican tradition on the one hand, and on the other, the languages of Expressionism and the Russian avant-garde in their search for a confrontation with European art.

In Italy: Valori Plastici, Novecento, Magic Realism, Antinovecento, Corrente

During the 1920s, Italy witnessed a proliferation of artistic movements. Some revolved around the "return to order" and the recovery of an artistic language whose roots lay in the past, like Valori Plastici and Novecento, or in the revival of the pictorial métier as in the case of Magic Realism, while others aimed at a recovery of the international avant-garde researches through small groups like Corrente which was connected to the larger Antinovecento movement.

In 1918, Mario Broglio founded the review *Valori Plastici* which gathered together Carlo Carrà, Giorgio Morandi, Giorgio de Chirico, and Ardengo Soffici. In a "return to order" climate, the group decided to reassess the great Italian tradition of painting, above all by a rereading of Giotto's and Masaccio's works. What the Valori Plastici group was seeking was an art which, unlike the international avant-garde, would recover the pictorial values used in the history of Italian art.

Their work was classical in composition, and conclusive, precise, and rigorously constructed in form. Drawing and colour were the primary instruments for composing a vision of the world that, although formally resolved, was divorced from all problems of modernity. The plasticity of the forms they so eagerly sought was to be understood as an attempt to define a pictorial reality that was endowed with its own particular solidity, thanks to their reassessment of the past.

A similar situation existed with the Novecento group which counted amongst its numbers artists of different tendencies, some even from the avant-garde, painters and sculptors of varying talent, who, during the mid-1920s, in keeping with the "return to order" and Valori Plastici, also advocated a need for art to draw on its own origins, on the "healthy Italian tradition."

Closely connected to Fascism, and supported by the regime's art critics, Margherita Sarfatti and Ugo Ojetti, the Novecento movement

did produce works of great value. Among those who adhered to the movement were Arturo Tosi, Mario Sironi, Marino Marini, Carlo Carrà, Achille Funi, Massimo Campigli, Felice Casorati, and Arturo Martini, who distinguished themselves by the quality of their work and the sincerity of their research. For those artists, painting and sculpture were instruments for meditation and not merely the means for demonstrating a purely technical virtuosity. Technique was not to be an empty mannerism nor a game of aesthetics, but a real pictorial language even if it was far from the innovative ideas of the avant-garde. The Novecento artists investigated the forms and materials of art incessantly in their endeavour to find a new way to conceive art. Art reckoned with its materials and the infinite repertoire of traditionally accepted forms, as well as with a past that did, however, confront and dialogue with the modern. This was evident in the works of Martini who, by starting from Canova's analysis of plastic rationality, arrived at a conception of sculpture that was an open, inventive plastic form and no longer aulic, monumental or celebratory like that of the contemporary official sculptors. In such a climate, Giorgio de Chirico became a reference point for a group of young artists that included Antonio Donghi, Ubaldo Oppi, Achille Funi, and Cagnaccio di San Pietro among others, who started the movement of Magic Realism.

These artists who advocated a return to the *métier*, and a desire to go beyond Futurism, were fully aware, however, that it was necessary to take into account the avant-garde experiences. De Chirico's role and the Metaphysical Painting he had invented were fundamental, as were his often repeated "recovery of the *métier*" and "beautiful painting". What distinguished the art of Magic Realism was its attentive study of museum paintings, particularly those of the sixteenth and seventeenth century for some like Donghi, however, interpreted through the language of metaphysics. The figures the artists painted were almost mannequins, "uneasy muses" which had been given a flesh and blood body. Their compositions, reminiscent of Neo-classicism in the purity of the drawing, the forms, and their solidity, while starting from reality, questioned it at the same time. There were, however, some artists who in a reaction against the climate of restoration chose to join the Antinovecento and the Corrente movements. Those artists who had no intention of adhering to the "return to order" when the regime's art critic, Ugo Ojetti, declared that "art had to be Italian", responded with a radicalisation of the regional artistic languages through a rereading of the pictorial researches of Impressionism and Expressionism.

The Scuola Romana (Roman School) was constituted in 1927 in Rome. At the heart of the group was Scipione, who worked together with Mario Mafai, Antonietta Raphael, Marino Mazzacurati and Fausto Pirandello. Their attention was focussed on French expressionist painting in particular. However, Scipione was also attracted by the expressive force of the Baroque, of which Rome was its greatest manifestation. By means of violent painting, he outraged seventeenth-century Catholic Rome on his canvas, but also exalted it in all its splendour as he compared it to the false Imperial Rome the Fascist regime was trying to revive. The historical city became a metaphor for the forbidden: the freedom of research and expression. In Turin, the group of Sei Pittori (Six Painters), among whom Carlo Levi, Francesco Menzio, Gigi Chessa and Enrico Paulucci, took French painting from Delacroix to Cézanne and Matisse as their point of reference, while in Venice, Pio Semeghini was attracted by Impressionism, translating his evocations of the lagoon into a luminous intimism. In Tuscany, Ottone Rosai delineated with his antirhetorical painting a provincial reality populated by common people and quotidian landscapes which were somewhat in the Italian tradition, but also comparable to the solid painting of Cézanne and the Expressionists.

In Milan, in 1939, Renato Birolli, Aligi Sassu, Giuseppe Migneco, Bruno Cassinari, Giacomo Manzù, Renato Guttuso, and others formed the Corrente group. Their common aim to dissociate from the general situation of cultural and moral degradation by finding a new pictorial language. Unlike the works of the Novecento artists, those of Corrente were charged with political and social tension and intensely dramatic in technique and themes where the representation tended to stress intellectual more than physical tension, and social more than the subjective tension.

In the World: New Objectivity, Socialist Realism, Mexican Mural Painting

New Objectivity (Neue Sachlichkeit) appeared for the first time in Mannheim in 1925 in an exhibition of the works of artists who had absorbed some of the German Expressionist solutions in their attempt to grasp and represent reality in a crude, at times tragically realistic and photographic manner, with the idea of depicting the dramatic situation of their times. It was certainly not by chance that the movement began in Germany during the critical period of the Republic of

Weimar, on the eve of the Nazi ascent to power, a prelude almost of the future nightmare.

George Grosz, Otto Dix, Hannah Höch, Max Beckmann, and George Scholz proposed images of an absolute realistic objectivity in which they concealed nothing in their works, hiding neither the horror nor the tragedy. Their painting did not seek the absolute beautiful nor the absolute ugly, only the absolute reality and truth. Their language derived from a lucid analysis of the extant and was expressed through a detailed, meticulous representation that called into question the current times, the failure of German culture, the crisis of bourgeois society, and the tragic rise to power of Hitler.

Grosz, through his strong, incisive, at times satirical and almost caricatural painting, depicted contemporary scenes in order to demystify the ruling class, by which he meant the political class, exposing it, ridiculing it, and underlining its absolute negativity and wickedness. Dix's work, on the other hand, crude, ruthless, and almost photographic, did not shrink before the horrors it described, but confronted them and depicted them with dramatic realism. An almost romantic character prevailed throughout Beckmann's works in which he used allegorical elements to depict the dramatic and apocalyptic fall of humanity. The tragedy that the New Objectivity artists narrated was that of the modern world and of contemporary society which was constantly struggling for its own development and its own survival; it was the drama of a subject that could not and did not know how to find itself.

In the Soviet Union of Stalin, after the adventure of the avant-garde movements that had accompanied the great political changes, art became an instrument for the use of party power and propaganda under the new regime. Many of the artists who had participated actively in the Revolution left the country (like Kandinsky, Chagall, Larionov, Goncharova, Gabo, Prevsner), some committed suicide, while others chose to move to the sidelines (Malevich) and leave the field open to painters for whom research had no interest, dedicated as they were to the representation and glorification of power. As a consequence, between 1932 and 1956, a state art developed in the Soviet Union, the so-called Socialist Realism.

Its tenets were set forth in 1934 by Andrej Zdanov with the establishment of the Union of Soviet Artists. Soviet Realism was to be an art that practised an exasperatedly realistic representation, using such recurrent subjects as the portraits of the leaders in "heroic" poses, and the proletarian masses at work, practising sports, or assembled at political gatherings. Its objective was to inculcate upon the people all those

principles that the government wished to propagandise. A decidedly celebratory and didactic spirit underpinned such paintings, one that had completely forgotten the recent avant-garde experience. The Soviet painters, Nikolaj Pagodin, Aleksandr Dejneka, Aleksandr Gerasimov, Nikolaj Semionov and others, aware they were serving their country's cause, confused art and reality, aesthetics and politics.

There was also a diffusion of a strongly ideological painting much like what was going on in the Soviet Union throughout the rest of Europe: in Italy in particular, painters with Communist leanings like Renato Guttuso, Ernesto Treccani, Lorenzo Vespignani, Giuseppe Zigaina, were working in a more original way than their Russian colleagues, aware they were part of history. In 1947, Guttuso adhered, together with others like Renato Birolli, Bruno Cassinari, Leoncillo, Ennio Morlotti, Armando Pizzinato, Giuseppe Santomaso, Emilio Vedova and Alberto Viani, the majority of whom were Communists, to the Fronte Nuovo delle Arti (New Front of the Arts) whose objective was to contribute through art to the reconstruction of the country. Amongst the Italian artists, the trend was away from the monumentality typical of Socialist Realism for they preferred to explore the human condition without falsity and mystification through painting and sculpture. That of the Italian artists was a moral condition and the task that lay before them was not to show the significance of an ideology but rather to interpret the proletarian struggle and the crisis of bourgeois society.

Piero Dorazio, Giulio Turcato, Carla Accardi, Antonio Sanfilippo, Ugo Attardi, Concetto Maugeri and Pietro Consagra, founded the Forma Uno (Form One) group in 1947, to which Achille Perilli, Lucio Fontana and Umberto Mastroianni also adhered. They in turn confirmed the need for artists to become committed to and involved in the social structure, all the while stressing, however, the autonomy of art and the artist's freedom with regard to his own linguistic research.

Placing greater attention on daily events, and moved by a conception of life and art of existentialist matrix and by means of a figurative painting that took Franco Francese as its departure point, existential realism developed in Milan between 1953 and 1955. Its first exponents were, amongst others, Giuseppe Guerreschi, Giuseppe Banchieri, Gianfranco Ferroni, Giansisto Gasparini, Bepi Romagnoni and Tino Vaglieri, who were later joined by Mino Ceretti, Alberto Gianquinto, and Floriano Bodini.

On the American continent, from the 1910s on, Mexico experienced its own political and cultural revolution. United with the peasants who were rebelling against the big landowners, the heirs of the Spanish

rulers, were the intellectuals and the artists who intended to contribute and restore the ancient civilisation of a country that had been destroyed by colonisation. The new post-revolutionary democratic governments attempted to give life to modern cultural reforms by collaborating with artists in order to encourage the people to participate in the development of the nation. By drawing on their common pre-Columbian origin, their hope was to stimulate a spontaneous creativity amongst the people.

The works they produced were distinguished by a figuration that was a constant reference to Mexican history, from its origins to colonialism, by means of cycles of paintings on walls (*murales*) and popular prints. The great themes of freedom, the liberation from colonial domination, and the salient facts of national history became subject matter for the works of artists like José Clemente Orozco, Diego Rivera, David Alfaro Siqueiros from the 1920s on.

Not only did the themes refer to tradition and popular history, but the pictorial techniques also went back to movements that were more people-oriented like German Expressionism and Constructivism. The narration in the paintings was impetuous, violent, and often tragic, and was executed with sharp, incisive lines and brilliant colours.

The Expressionist lesson was most evident in Orozco, less so in Rivera who, however, thanks to his European formation, interpreted the modern spirit by re-proposing the French artistic languages. In Siqueiros, on the other hand, a strong Surrealist influence was present, since he considered that movement much closer to his own idea of revolution which he interpreted as an unending event that was relative to the whole world and not just one's own nation. The revolutionary significance of Surrealism was picked up in Siqueiros's works as the struggle of an oppressed people's vital instincts against the nauseating libido of power. Tragic and sublime tensions intermingled in the works of these mural artists: it was the expression of a new intellectual and formal force, and after the Second World War, the artists in the United States re-examined that Mexican experience as they reflected about the drama of the modern world in their own works.

The Return of the Avant-garde

After the Second World War, Europe went through a profound social and cultural crisis, a crisis of identity that led to its abdication of its role as the vital centre of international artistic research, which then moved to the United States. Paris, the pulsating heart of culture

Marcel Duchamp,
Bicycle Wheel,
1913. Sidney Janis
Gallery, New York.

Kurt Schwitters,
Orbits, 1919.
Marlborough-
Gerson Gallery,
New York.

Francis Picabia,
Novia, 1919-22.
Private collection,
Milan.

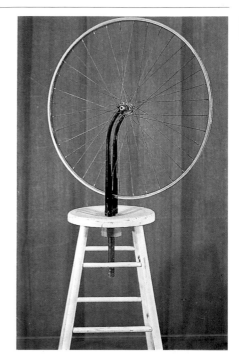

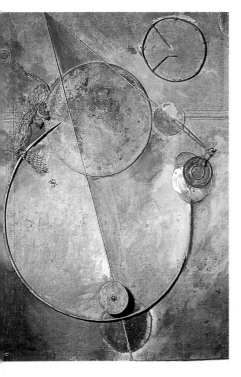

Joan Miró,
Harlequin Carnival,
1924-1925. Albright
Knox Art Gallery,
Buffalo.

Salvador Dalí, *Six
Apparitions of Lenin
on a Piano*, 1931.
Musée National
d'Art Moderne,
Centre Georges
Pompidou, Paris.

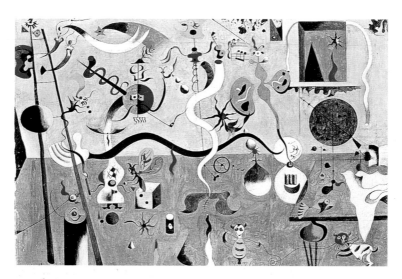

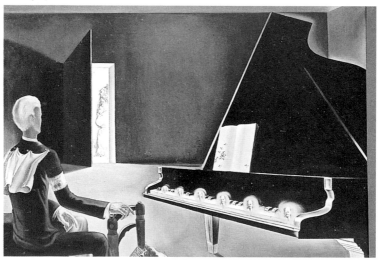

Max Ernst,
*The Veiling of the
Bride*, 1939-1940.
Peggy Guggenheim
Collection, Venice.

René Magritte,
*The Human
Condition*, 1933.
Private collection,
France.

Amedeo Modigliani,
*Paul Guillaume
Seated*, 1916. Civico
Museo d'Arte
Contemporanea,
Milan.

Arturo Martini,
Nena, 1928. Private
collection, Varese.

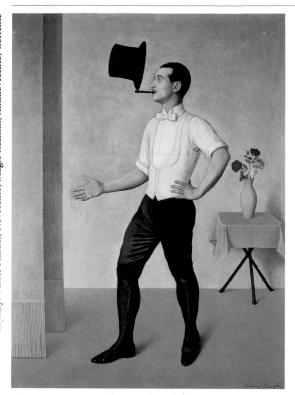

Antonio Donghi,
Juggler, 1936.
Banca di Roma
collection. Rome.

Renato Birolli,
Eden, 1937.
Civica Galleria
d'Arte Moderna,
Boschi collection,
Milan.

Otto Dix,
*The Merchant
Alfred Flechtheim*,
1926.
Nationalgalerie,
Berlin.

George Grosz,
Grey Day, 1921.
Nationalgalerie,
Berlin.

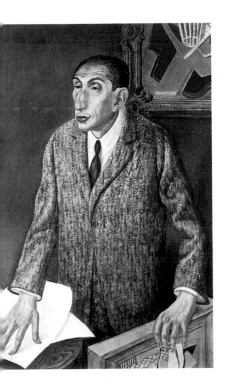

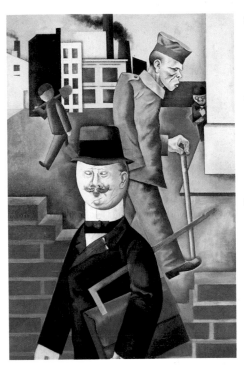

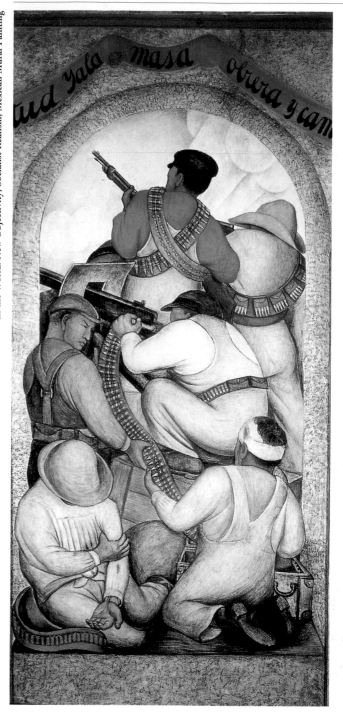

Diego Rivera,
*The Distribution
of Arms,* 1928.
Ministry of
Education, Mexico
City.

Jackson Pollock,
Blue Poles, 1952.
Ben Heller
Collection, New
York.

Clyfford Still,
Painting, 1957.
Kunstmuseum,
Basel.

Mark Rothko, *Ochre and Red on Red*, 1954. The Phillips Collections, Washington, D.C.

Willem De Kooning,
Escavation, 1950.
The Art Institute,
Chicago.

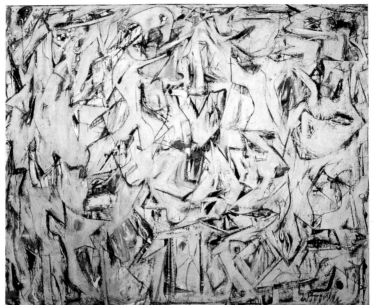

Ad Reinhardt,
Composition, 1960-
966. Private
ollection. New
ork.

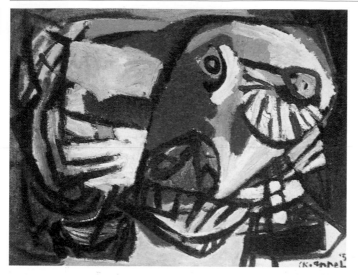

Karel Appel,
The Owl, 1953.
Galerie Ariel,
Paris.

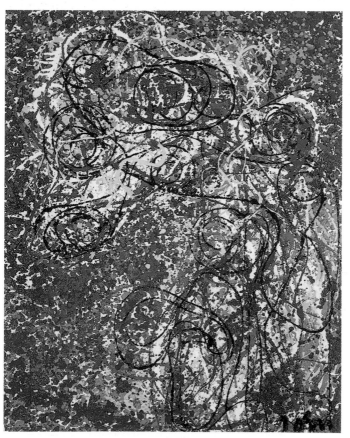

Asger Jorn,
*The Great
Sommobody within
the Omniboss,* 1961

Jean Dubuffet,
The Extravagant,
1954. Private
collection, Paris.

Jean Fautrier,
Slough, 1946.
Private collection,
Milan.

Emilio Vedova,
Cat's Paw, 1953.
Giorgio Marconi
collection, Milan.

Antoni Tápies,
Black Horizontals,
1960. Martha
Jackson Gallery,
New York.

Alberto Burri,
Combustion BR,
1964. Private
collection, Milan.

Arnaldo Pomodoro,
*The Traveller's
Column*, 1961-62.
Giorgio Marconi
collection, Milan.

and art, above all the art of the nineteenth century and the first decades of the twentieth century, lost its centrality to New York. There is no doubt that the reasons for such a drastic change were to be found in issues of a social, political and economic nature rather than an artistic one. The young American artists, the heirs of the European avant-garde with whom they were in contact when many moved to the United States, started to express themselves with pictorial languages in the 1930s that, although linked to the European ones, sought their own autonomy and had a disruptive expressive force.

The revival of the avant-garde languages on the part of the American artists, like that of the Europeans and in some cases of the Japanese, was the revival of a research which was not meant to be a nostalgic glance backwards, but rather a sincere acknowledgement of the important role the European avant-garde movements played at the beginning of the century. The younger artists felt a need to measure up to them, to depart from where the avant-garde artists had been forced to interrupt their research, not because it was culturally impossible to continue it, but because it had been suffocated by political and social factors.

The young artists turned their eyes to Surrealism, Dadaism, Abstract Art, and even the great innovative pictorial form of Cubism; they confronted these knowing full well that it was necessary to find an answer in terms of research. Just where was one to start in America or in Europe in order to continue to operate according to the idea of an evolution of artistic language, if not from the foundations of the avant-garde? The revival of the avant-garde languages after the war thus gave rise to an infinite series of movements which absorbed their theories, forms and ideologies, as they questioned reality and defined a language of an art that in its incessant research and evolution attempted to interact with the world so as to change it.

Abstract Expressionism, Action Painting, Colour-field Painting

During the 1940s and 1950s, Abstract Expressionism, although particularly American in character, also spread throughout Europe albeit in a diverse manner. Taking some of the European avant-garde movements as their departure point, different artists attempted to arrive at a new language through a reconsideration of the materials of painting. No longer was the canvas

49

a place of representation, it became a vital space of action, in the same way that the materials, for the most part industrial paints, became tools for that action. All those energies and instincts of the artist, as the subject, and of the social fabric, converged on the canvas. The convulsive gesture of Pollock, and its opposite, the calm spirituality of Rothko, represented the two poles of a language that was increasingly trying to express on canvas a need to do, to act, and to live.

After the Second World War, artistic research in the United States established itself with an extraordinary expressive force. Through a rereading of the European avant-garde movements, and a study of the works of Arshile Gorky which represented a bridge between Europe and America, the new expression in American art began to define itself. By rejecting the Regional painting of the 1920s and 1930s, and by recognising the existential and social solutions present in artistic expression, research in America rapidly became autonomous with respect to that in Europe from the 1940s on.

The Abstract Expressionists drew on eclectic sources: 1) Surrealism with its concern for the unconscious which for the Americans represented not only the unconscious of the single individual but the collective unconscious of society, 2) myth and primitive art, 3) the primary, archetypal forms of existence (Jung), and 4) the spirituality of Kandinsky's painting.

The term Abstract Expressionism was first used by the critic Robert Coates in 1946, specifically in reference to the New York School. It was not so much a movement that united artists of similar styles, as a cultural and existential attitude. Apart from individual formal and stylistic characteristics, the artists were spurred by the need to bring the search for an identity into each individual work even if it was even of a collective or social order. Personalities of different formation and sensitivity were active in that climate the fulcrum of which was New York: Jackson Pollock, Willem De Kooning, Adolph Gottlieb, Robert Motherwell, Sam Francis, Mark Rothko, Ad Reinhardt, Franz Kline, Philip Guston, Barnett Newman, and Clyfford Still.

Common to all, even in its diversity, was the new way of understanding the pictorial plane. The canvas became a space to act in more than to construct, and the colours, in some cases synthetic and industrial, became tools together with the gesture of that action. Harold Rosenberg, the critic who theorised their research,

wrote in *The Tradition of the New*: "At a certain point the American painters, one after the other, started to consider the canvas an arena to act in instead of a space in which to reproduce, redraw, analyse or 'express' a real or imagined object. The canvas was therefore no longer the support of the painting but, on the contrary, an event." What was fundamental in this shift, in this new way of treating the canvas as a space to act in, whether frenzied as in Pollock's work or calm as in Rothko's, was to have reached a new language which was autonomous to that of Europe.

The gesture of the Abstract Expressionists derived from a kind of Surrealist automatism, in which the artist's own experience and past took shape on the canvas in a sort of vital expressive flow. Pollock and Rothko represented the two poles of this action or confluence of energies on the canvas. Pollock used a convulsive body action, as in a frenetic dance or bull fight, as he dripped paint onto the canvas, its rhythmic course produced by the jerking movements of his body. His action painting (a term coined by Rosenberg in 1952 to describe Pollock's technique) produced extraordinary works like *Blue Poles* in 1952 in which the artist constructed a kind of "landscape" in which everything depended on the physical gesture and the pictorial material. Nothing was accidental in his work as one might suppose; on the contrary, he was in total control of his body and his gestures as he manipulated them in harmony with the colour-material. In this painting as well as in others from the same period, the surface was covered all over with drippings that overlapped and interlaced as if the artist's own existence were at stake in the continuous accident of the form.

Rothko, on the other hand, seemed to move in an opposite direction, although his luminous, almost monochrome paintings that referred to an unexpected placidity in a climate of frenetic "action", possessed an even more violent action, the action of an existence that interacted with space and influenced it through painting. In *Ochre and Red on Red* of 1954, the artist painted the canvas calmly and diligently, like some conscientious housepainter, playing on the passage of light through the ochre and the red to construct a work that was light and space, the emotional force of colour and the pulsating intensity of the plane. His painting was without a subject, without a form, it was a material and spiritual action that attempted to knock down all the architectural limits defining it. The canvas influenced the space around it, involving and amplifying it. *Chapel*, executed in Houston, was a "sacred" space the walls and

ceiling of which were entirely covered with canvasses of a dark yet luminous painting that opened the doors to an absolute spirituality. Rothko's position can be considered exemplary and representative of that group of Abstract Expressionists who reacted against the dramatic gesturalism of action painting by cooling the pictorial plane and the gesture.

Supported by the critic Clement Greenberg who, in 1962, defined their art as "colour-field painting", Barnett Newman, Clyfford Still, Mark Rothko and Ad Reinhardt brought substantial changes to action painting and became the mystic and ascetic, or more "theological" wing of Abstract Expressionism. Reacting against the proliferation of marks and colours of Pollock and De Kooning, they reduced the lines and colour so as to create, in some cases, rigorous monochrome works whose planes, the colour-field, stretched to infinity. In 1946, Clyfford Still wrote: "I showed that one single stroke of colour, sustained by work and a mind that understands its power and implications, could restore to man the liberty he had lost in twenty centuries of excuses, expedients, and enslavement." His was no doubt an exasperated point of view, even if the reduction of the chromatism of the work opened the space of the painting to an idea of infinity that stretched beyond the work itself. While the influence of the European avant-garde was evident in the works of the colour-field painters, even more evident was the influence of American culture and landscapes with horizons so vast they seemed endless and a wide open sky that brought infinity to mind. Thus the canvas became a vast colour field that extended over its own borders, where there was no distinction between subject and ground since both were resolved in the pictorial gesture. Ad Reinhardt and Barnett Newman departed from a logical and analytical principle, put forth in their theoretical texts as well, in which, by analysing the pictorial structure, they reflected and defined the more conceptual aspects of art. Reinhardt's was almost a declaration of intent with respect to the Suprematist painting of Malevich. The reduction in his paintings occurred by degrees until it became totally black, "the last painting that can be painted", the black cross on the black ground: the end of the expressive possibilities of painting. Reinhardt meditated about a pictorial language that, once its expressiveness had been silenced, became an investigation of the language itself: art referred to art, painting to painting.

As for Barnett Newman, he reacted to the expressiveness of action painting by reducing his emotional involvement in the work to a

minimum while emphasising the notions of space and the visual field as essentials for the painting and its own identity. During the 1960s, other more radical artists joined them, among whom, Morris Louis, Kenneth Noland, Helen Frankenthaler and Ellsworth Kelly who, in the "Post Painterly Abstraction" exhibition held in 1964, presented works in which they further reduced colour to the primary and essential while the painting became an impalpable, immaterial veil.

Art Brut

In 1945, the French artist, Jean Dubuffet used the term "art brut" to describe all those works that had been painted by those who, whether by their own choice or not, had nothing to do with the culture or commercialisation of the world of art. His label included everything that was spontaneously generated through free expression and the sole need to recount oneself and the world.

"Not only do we refuse to pay respect to cultural art, and not only do we refuse to consider the works in this exhibition inferior, but we maintain, on the contrary, that as the fruit of solitude and a pure, authentic creative impulse (uninfluenced by any desire for competition, applause or social success), they are more precious than those created by professional artists. [...] Indeed, in front of these works we experience the sensation that cultural art is, on the whole, the toy of a futile society, a deceptive parade." Thus wrote Jean Dubuffet in the introductory essay to the huge exhibition he organised at the Musée des Arts Décoratifs in Paris in 1967, where he showed the works of 135 "artists" which he had been collecting over the years under the label of "art brut", and which followed the first exhibition of 1947 when he first formulated the term to describe the countless examples already in his possession (and now conserved in a museum devoted to them in Lausanne).

What did Dubuffet mean by such a term? And who were the authors whose works he patiently assembled, catalogued and exhibited? By the term "art brut" the French artist meant all those works produced by the free expression of the individual, and free from the rigid rules governing the structures of art, both cultural and commercial. Dubuffet maintained that only spontaneously generated works could be authentically true and truly represent artistic ex-

pression for they ignored the official languages of art and criticism. The people whose work he diligently collected lived as a rule outside the established art world and included the mentally ill, the elderly, proletarians, hermits, all those who expressed their innermost creative impulses through art. They used the most disparate materials (during the 1950s, Dubuffet himself employed non-traditional materials in his own works) to create paintings, compositions, sculptures that were in themselves, albeit unconsciously, characteristic of the cultivated contemporary world. In Art Brut works, like those of Dubuffet himself, the frenzied elementary marks, colours, and materials became an instrument of consciousness, a rebellious aesthetic path that submitted to the rules of the artistic world with difficulty.

CoBrA

CoBrA was the name of a group that was founded in Paris in 1948 by Jorn, Pedersen, Alechinsky, Corneille, Appel and Constant. Characterised by an intense experimentalism, violent chromatic brushwork, and the mingling of abstract and figurative elements, it proposed to bring art back to its primary, pre-linguistic and pre-technical stage, in which it could only be expressed by means of the pictorial gesture.
Jorn subsequently adhered to the Situationist International, founded in 1957, and went on to further define the experimental and primary aspects of the pictorial gesture that had already been present in CoBrA.

At the end of the 1940s, some artists in Europe also became interested in the gesturalism of American Expressionism, to which they added individual characteristics from their own cultural backgrounds. In 1948, the CoBrA group was founded in Paris (from the names of the three native cities of the artists making up the group: Copenhagen, Brussels and Amsterdan), by the Danes Asger Jorn and Carl Henning Pedersen, the Belgians Pierre Alechinsky and Cornelis Corneille, and the Dutch Karel Appel and Benjamin Constant. What differentiated this group—whose roots went back to the groups, Surréalism Révolutionnaire (Belgium), Reflex (Holland), and the abstract-surrealist movement Host (Denmark)— from the contemporary American ones was an exasperated experimentation that was carried to the extreme, marked by incisive, vio-

lent brushwork, the use of dark colours, and an imagery based on primitive and folk art which blended the figurative with the abstract. Midway between the Dadaist approach and a questioning of the purist research of Mondrian and De Stijl, the CoBrA exponents sought the truth of art by returning to a pre-linguistic, pre-technical stage which was expressed by the violence of the gesture. "The act of creation is in itself more important than the object created, and the latter acquires a meaning to the extent that it bears within it the traces of the work that generated it."

This was their philosophy, and their works, although dissimilar, departed from those premises. "A painting is not a construction of colours and lines, but an animal, a night, a man, and all of that together."

In their works, whether abstract or figurative, the representation of the object was cancelled in order to express a primary state in which the language of art was to be found again in the material and its innumerable potentialities.

In 1953, Asger Jorn founded the Movement for an Imaginist Bauhaus in Switzerland which was in diametric contradiction to the Gestalt research of Max Bill, which Enrico Baj and the Nuclear Movement group joined the following year. Jorn subsequently adhered to the Situationist International, founded in Paris by Guy Debord in 1957, and represented its artistic element together with Constant and the Italian Pinot Gallizio. The Situationist movement was of a Surrealist and Lettrist matrix since it borrowed their ideologies in order to formulate its own theories and actions. In its analysis and criticism of contemporary society, the Situationists elaborated an artistic theory in which all the aspects of collective life making up the metropolitan system were questioned. From these were deduced concepts like *urbanisme unitaire*, conceived as a system of integrated city life, *détournement* (diversion or deplacement), and *dérive* (psycho-geographic drift).

The artworks resulting from such principles were meant to break the barriers between all genres and styles and create a *dérive* between the individual and society.

Both Jorn, with his pictures "détournes", and Gallizio, with his "industrial painting", created works in which common stylistic elements were eliminated so as to favour a flow of actions, in which the authorship and the concept of originality were detracted from the work itself, giving it an impersonal, industrial mark, but one that was also spectacular and theatrical.

Art Informel

Art informel was neither a movement, school, or tendency; it was more of a condition or mood that traversed Europe in the early 1950s, involving art as it passed through Existentialism. More than anything else it was an action in the world, an existential given that forced the artist to act and interact with all the materials offered by reality. In its liberation from formal figurative and geometric modes, *art informel* meant painting to be of materials, signs, and in some cases gestures, in order to find a new relationship with the world through art.

Right after the Second World War, given the Existential climate pervading Europe, art began to be looked on as a means of action or a way to operate in the world by making use of its materials rather than a theoretical instrument that could influence reality. In such a situation, between the late 1940s and the early 1950s, *art informel* made its appearance.

A similar approach was also adopted by some Japanese artists, Kazuo Shiraga, Yiro Yoshihara, Shozo Shimamoto and Sadamasa Motonaga, who founded the Gutai group around 1950, and subsequently by Hsiao Chin who was then working in the West. In addition to their total adhesion to *art informel*, those artists are also to be considered the major precursors of the Happening.

Art informel was a cultural and existential condition, an inner state more of man than of art; it was a moment of existence that witnessed the confluence of authors from different backgrounds but who were close to one another as far as the conception of art was concerned. They looked on art as an instrument which, after the collapse of the great ideologies and goals of the Western world, could restore action to the subject, a practical, concrete, yet cognitive action rather than a theoretical one.

The critic Michel Tapié spoke of "art informel" for the first time at an exhibition curated by him in Paris in 1951 when he presented the works of Jean Fautrier, Jean Dubuffet, Pierre Soulages, Wols, George Mathieu, Hans Hartung and others as the expression of that new research. Italy soon became involved with Alberto Burri, Emilio Scanavino, Ennio Morlotti, Emilio Vedova, Afro, Giulio Turcato, Arnaldo and Giò Pomodoro, Agenore Fabbri, Salvatore Scarpitta, as well as Antoni Tápies and Antonio Saura in Spain, and Emil Schumacher in Germany. In Italy between 1953 and 1955,

the critic Francesco Arcangeli represented a group of artists that included Ennio Morlotti, Pompilio Mandelli, Vasco Bendini, Sergio Vacchi, Mattia Moreni and Alfredo Chighine, whose works were of an *informel* matrix but whose intention was to elaborate landscapes existentialistically.

What united these artists in addition to the poetics of the action, that is, acting in the world by means of the expressive force of the gesture, was their particular interest in disparate materials which were elements of an extraordinary emotional and expressive capacity in their opinion. They chose the materials because of their morphological characteristics and the different tensions distinguishing them. The various materials employed in the works (jute sacks, lumps of colour, shavings, as well as a variety of superimposed materials) became the tools of a new artistic language.

Each material had its own history and its own life, and was therefore the expression of the flow of its own existence, condition and language. The works of the *informel* artists, somewhat like geological strata, demonstrated the act of the world's becoming as well as their own by means of the relationships of materials and the tensions of the pictorial gestures.

The images proposed by Dubuffet referred to a figurative reality, but his beings were created by an incisive gesture, a sign that acted on the material and forced it, in an act of truth, to show itself for what it really was. The ground and the figure were generated from the same material, from a writing or hypothetical lexicon that almost comically surfaced from the painting.

In the anguish-charged works of Tápies, on the contrary, the sign penetrated the material in order to define it as such. All the materials that the artist used, plaster, bars, crosses, handprints in cement, and still others, served to declare that the material itself was a sign, the trace of a tragic and "negative" existence of which the painting was not a simple representation, but an anti-picture that went so far as to show its own wooden frame, as in *Horizontals in Black* of 1960.

These problems were central to Burri, too. In his works, made with jute sacks, pieces of burnt wood, and paper or plastic, he attempted to transform the material, not to represent something beyond it, but to represent the material itself, for its formal, chromatic, and emotional characteristics. For Burri, a painting was material displaying itself as a form-material. The patches, burns, and tears in the material were the evidence of a continual torment. In 1952, in

Italy, the group of Eight (Afro, Renato Birolli, Antonio Corpora, Mattia Moreni, Ennio Morlotti, Giuseppe Santomaso, Giulio Turcato and Emilio Vedova) formed around the critic Lionello Venturi, with the intention, within the controversy between the abstractionists and realists, to dissociate from such an antinomy by proposing a painting that had merit because of its lines, colours and internal force. In his works, pervaded by a violent gesture, Vedova underlined his intention to establish a relationship of profound knowledge of the world.

Happening

Happenings were events or actions that intended to open artistic expression to reality. Referable to the Dadaist performances at the Cabaret Voltaire, the Happening first made its appearance on the American artistic scene in 1959 at Allan Kaprow's show. His Happening was composed of a number of autonomous parts that constituted a unity in the assemblage of the event. Kaprow made use of all kinds of materials, both artistic and not, in order to relate art to life, and the artwork to reality.

Happenings were defined as events or occurrences that were linked to specific times and places. With the introduction of the Happening, American art called into question all those Abstract Expressionist values that based the artwork on the gesture, and produced a concrete object, the painting. After having created some environments between 1957 and 1958, Allan Kaprow, an American of Russian descent, presented his *18 Happenings in 6 Parts* in New York in 1959, a work that in some aspects was reminiscent of a theatrical event. However, unlike the theatre, the Happening developed according to variable schemes and was based on a structure of "watertight compartments." Something different and extraneous to the others took place in each compartment at the same time, yet all the actions were connected in the event itself. Professional actors performed or improvised simple, elementary actions, declaiming sentences or just words as sounds and noises interacted without any pre-arrangement.

External factors could intervene in a Happening, variables dictated by pure chance which would effect a sudden new development. Unlike the theatre, where it was necessary to follow the play and rules of recitation, the Happening was based on improvisation, on the

author's loosely-defined outline, and did not represent a set, repeatable structure inasmuch as it was subject to the laws of chance. The event was everything; it was open and free to develop in a totally new way, and since it was also influenced by audience participation, the very structure of the work was constantly changing. Words and things intermingled with noises and gestures on the same plane where nothing prevailed, and all the elements converged to search for a language that was open to any and all possibilities and interactions.

Kaprow was soon joined by artists like Jim Dine, Lucas Samaras, Claes Oldenburg, Robert Whitman, Red Grooms, Robert Rauschenberg, and the composer John Cage. The collaboration between Rauschenberg, Cage, and the choreographer Merce Cunningham had already produced important events, one of which was the 1952 Happening at Black Mountain College where painting, music and dance interacted to the maximum of their expressive and formal possibilities.

The heterogeneous and multi-disciplinary Happening recalled the Dadaist Cabaret Voltaire performances, or some of the works of Kurt Schwitters like *Merzbau* in which the idea of art as a continually evolving action was introduced, or even the works of the Co-BrA group. By taking part in the linguistic adventure of art, the Happening manifested the need to step over the narrow limits of the artwork, be it painting or sculpture, in order to join the continuous flow of the world by following its dynamic incentives. The relationship between the artist-individual and the environment became increasingly defined, and the exchange between them resulted in artwork-events that attested to the capacity of the artwork to become part of reality. The Happenings questioned the figure of the artist as a technician of a language in order to underscore a role that because it was aesthetically sensitive made him intervene in the world in order to activate it in a continuous play of emotions and forms.

Fluxus

In 1961, George Maciunas, together with Dick Higgins and others, founded the Fluxus movement, which was characterised by the complete openness of its artistic language to all the materials in the world and all the flows of existence. The works of Fluxus were actions or events that tended to underline how the routine and ba-

nal in each individual's life could be regarded as an artistic event for, as Maciunas said, "everything is art and everyone can do it."

By putting into practice the theories of George Maciunas (according to whom everything was art, and art also had to deal with the insignificant as well as be amusing and accessible to one and all), and Dick Higgins ("Fluxus is not a movement, an historical moment, an organisation. Fluxus is an idea, a way of life, a loosely-knit group of people who execute 'fluxus-works'."), the international Fluxus movement was established in 1961. The free spirit of the group was already quite clear from its declarations, while a multiplicity of artistic expressions like painting, sculpture, Happening, dance, music, poetry, theatre and technology converged in all its works and actions.

Fluxus was a movement that was open to everyone, and numerous artists from all over the world adhered to it: Nam June Paik, George Brecht, Wolf Vostell, Robert Filliou, Ben Vautier, Daniel Spoerri, Yoko Ono, Joseph Beuys, La Monte Young, Henry Flint, Charlotte Moorman, Robert Watts, Gianni-Emilio Simonetti, Giuseppe Chiari, Sylvano Bussotti, and the Japanese Gutai group. They proposed a total art in which the mixture of expressions would generate a vital fluidity, as undetermined as the events of daily life were, and reiterated, in keeping with the historical avant-garde spirit, the identity between art and life.

The movement in fact traced its roots to Dada and Duchamp, as Maciunas himself pointed out in the Fluxus genealogical tree, and its aim was to involve all of reality. Maciunas declared in its manifesto: "Purge the world of the forms of bourgeois life. Know how to promote Reality." Fluxus activity involved the different art forms in which simple every day activities like sitting, smoking, breathing, and talking were interlaced in a structure in which art and life together created the work or the event.

Musical research had a particular importance in Fluxus for it exploited the capacity of some simple objects to generate sounds (a whistling teakettle, a clicking typewriter, a ticking metronome, etc.) which were then intersected with more "musical" instruments in order to produce the work. John Cage's research was instrumental in such an environment even if his position was autonomous with respect to the movement. Cage, who elaborated his own theory by following the teachings of Zen philosophy and by eliminating any kind of personal or emotional involvement in the musical structure and in its execution, defined the capacity of a sound or noise to be present

in an artwork as it was in life. The execution of passages composed by the musician was determined by elements that varied from time to time so that new results were constantly being obtained given the diversity of the instruments and performers. In September 1962, after Maciunas's first New York show, he organised the "Fluxus internationale Festspiele neuester Musik" in Wiesbaden, which was followed by others throughout the world. In the same year, the artist started to publish the *Yearboxes* in which he collected the testimonies of Fluxus exponents world-wide. It is not venturing too much to say that, apart from the other artistic personalities who played active roles in the movement, Fluxus was Maciunas himself: he was its creator, theoretician, editor, promoter, organiser, and was recognised as such by his fellow companions.

Art Outside the Movements

The twentieth century, marked by a proliferation of controversial avant-garde movements together with moments of restoration, within which the artists were always able to carry out their work, was also characterised by the contribution of individual figures, who were autonomous in their research and artistic practice, albeit that autonomy of language in the majority of cases derived from the avant-garde.

The multitude of individual researches that had already developed at the École de Paris contributed to the creation of an extraordinary cultural climate and a particularly intense period in the international panorama of art. Amedeo Modigliani, Constantin Brancusi, Alberto Giacometti, Louise Nevelson, Roberto Sebastian Matta, Alexander Calder, Wilfredo Lam, Serge Poliakoff, Nicolas de Staël, Balthus, Henry Moore, Francis Bacon and Graham Sutherland were only a few of the numerous artists who, at different times in Europe and in America, chose total freedom of expression and independence while respecting other movements and avant-gardists. Even after the Second World War, artists continued to produce works of noteworthy importance that were both figurative and abstract and expressive or scientific, while not personally identifying with any particular movements, schools or groups.

Expressionism, Cubism, abstraction, and Surrealism were studied and interpreted by different artists according to their own personal ideas about art and subjective visions of the world leading to results of an extraordinary expressive force. By reviewing all the languages of avant-garde derivation, the individual artists were able to borrow

ideas from the different movements for their own original research. In Europe and America, the neo-avant-gardes continued along their own paths as they defined new scenarios, and together with their newer figures and signs, the paintings and sculptures of individual artists contributed to the creation of an international and heterogeneous climate, one that was rich in new formal solutions that eschewed the idea of a specific movement by stepping over the narrow confines of their common paths. The individual artist was free to ignore the rigid theories of movements in order to follow a path for which individual research was deemed inevitable and necessary. The different viewpoints and artworks of those who worked alone in order to contribute to the development of art combined with extraordinary force to develop more global and collective languages.

Spatial Art

Founded by Lucio Fontana between the late 1940s and the early 1950s, the Spatial Art movement attempted to effect a fusion between the world of art and the real world so as to create an exchange that would produce an artistic event. It also tried to define an idea of space in relation to the work, intended as the evolution of the material in space in which no separation existed between the pictorial plane, the plasticity of the sculpture, and the space around the work.

With the declaration "We sing the evolution of the means of art", contained in the *Spatial Art Manifesto* of 1951, Lucio Fontana, Roberto Crippa, Mario Deluigi, Gianni Dova, Virgilio Guidi and Cesare Peverelli founded the Spatial Art movement, to which Tancredi and Giuseppe Capogrossi (who had founded the group Origine in 1949 with Ettore Colla and Alberto Burri) also adhered. In 1946, Fontana had already analysed a series of prospective problems regarding the movement itself in the *Manifiesto blanco* (which was followed by others up to 1953).

That declaration was based on a certainty: that art had always been bound to the evolution of its own means, and had to know how to use them in order to reach a language capable of transforming them into an artistic instrument. Among the means that reality placed at the disposal of the artist, space was first and foremost. Fontana was convinced that each consciously produced thing was "a making of space", whence the name of his movement. Making space meant

eliminating any idea of representing space itself; it meant creating space without representing it.

If the painting was the plane, then the space obtained eliminated that plane, puncturing it and wounding it, opening it, and interrogating it inasmuch as it was a plane; and if the sculpture was a volume and its ideal the sphere, it was necessary to destroy that equilibrium by making violent incisions in the material, with the intention of emphasising the total redefinition of space by means of a gesture that broke the form. In painting as in sculpture, the gesture was an action on the plane and the volume that placed the front and the back and the interior and the exterior in clear communication, creating a continuity between the spaces on both sides of the plane and the form. Between 1949 and 1969, Fontana also executed a series of "ambiences" in which the space was a whole room that the artist painted entirely in black, underscoring its infinite formal possibilities with the aid of Wood light. Spatial Art was not meant to be a scientistic movement. Although it considered science and its relationship to art, it did not raise questions of a rational-scientific order, choosing rather to explore the evolution of the language of art in modern times. Art therefore did not avail itself of linguistic elements that were extraneous to it in order to define itself, but investigated itself by using its own materials and concepts. The space that Fontana and his friends spoke about was the space of art, knowing full well that art had to measure up to the concepts and materials of its own time. The gesture of the Spatial artists, although it apparently eliminated the traditional elements of art, painting and sculpture, was a profoundly cognitive and intellectual gesture that could define itself through the work of art.

Nuclear Movement

Founded in 1950, the Nuclear Movement was based on a consideration of its own contemporaneity, and particularly interested in research on the atom. Its aim was to construct a hypothetical "nuclear landscape" by means of a greater experimentation of materials and techniques. The disintegration and fragmentation of material was its main theme of investigation, and its representation was the content of the work of art.

In 1950, Enrico Baj, Joe Colombo and Sergio Dangelo formed the Nuclear Movement in Milan. The term referred directly to its own matrix, the nuclear problem present in society at that time, and

artists were encouraged to question themselves about its positive and negative effects. By observing the present, they hoped to make a hypothesis about a future that seemed increasingly dark and disquieting. The Nuclear artists took Surrealism and psychic automatism as their departure points as they attempted to contrast abstractionism and naturalism in order to represent the disintegration and fragmentation of material pictorially. Experimenting freely with the materials of painting, they explored its structures, combinations, and a wide variety of uses and techniques. Baj, more than anyone else, adopted an indifferent and indistinct use of techniques and materials including tachisme, frottage, drip painting and collage, as he combined diverse materials in unusual and bold mixtures in an attempt to create a hypothetical nuclear reality on the canvas.

In the movement's manifesto, published in Brussels in 1952, the three artists, who had been joined by others in the meantime, Asger Jorn for one, originally a member of the CoBrA group, declared that it was possible "to re-insert painting by referring to the nuclear situation and the search for a new truth, by now residing in the atom."

Neo-Dada

The term Neo-Dada refers chiefly to the work of two American artists, Robert Rauschenberg and Jasper Johns, whose experimentation with art, starting in the early 1950s in New York, was along Dadaist lines. By making use of instruments specific to art, namely painting and sculpture, and combining them with materials and objects they had found in the real world, the Neo-Dadaists meant to underscore the need for a confrontation with reality in order to give life to an artistic language that could confront it.

It was the aim of Robert Rauschenberg and Jasper Johns, who formed the Neo-Dada movement in the early 1950s in New York, like the historical Dada avant-garde, to create works that had in themselves a totalising spirit, works in which objects and forms from the real world, from everyday life, could come together. The Neo-Dadaists theorised that abandoned objects, the junk of a world that man and the industrial process had completely transformed, the rubbish piled high in enormous city dumps, constituted a new landscape form and could be employed to make art. Nature, which had always been a source of inspiration for art, was transformed into culture.

Allan Kaprow,
18 Happenings in
6 Parts, Part 4,
Room No. 1: the
Orchestra, 1959.

Joseph Beuys,
The Pile, 1969.
Herbing collection,
Germany.

Alexander Calder,
Mobile, 1960.
Giorgio Marconi
collection, Milan.

Louise Nevelson,
Night Sun I, 1959.
Giorgio Marconi
collection, Milan.

Lucio Fontana,
Spatial Concept,
1962. Giorgio
Marconi collection
Milan.

Enrico Baj,
Painting, 1953.
Private collection,
Milan.

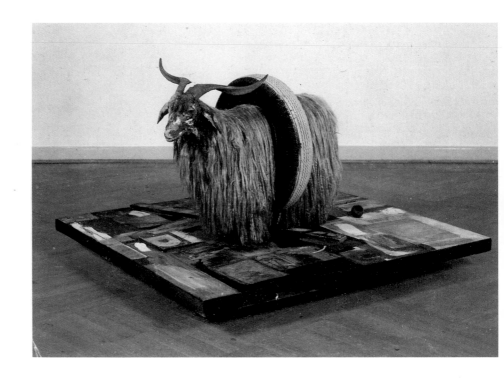

Robert
Rauschenberg,
Monogram,
1955-1959. Moderna
Museet, Stockholm.

Jasper Johns,
Flag, 1954-1955.
The Museum
of Modern Art,
New York.

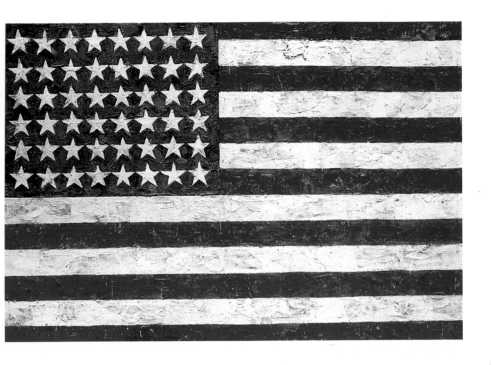

Yves Klein,
*Monochrome bleu
IKB, 175*, 1957.
Musée d'Art et
d'Industrie, Saint-
Etienne.

Jean Tinguely,
Baluba XIII, 1961.
Wilhelm-
Lehmbruck-
Museum, Duisburg.

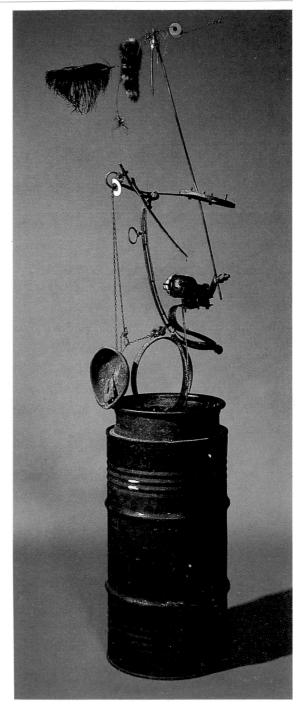

Mimmo Rotella,
Point and A Half,
1962. Galleria Giò
Marconi, Milan.

Jesus Raphael
Soto,
Metamorphosis,
1954. Museo de
Arte Moderno,
Fundación Soto,
Ciudad Bolivar.

Victor Vasarely,
Composition, 1962.
Galleria Notizie,
Turin.

Piero Manzoni,
Achrome, 1957-58.
Giorgio Marconi
collection, Milan.

Gianni Colombo,
Pulsating Structure,
959. Galleria Giò
Marconi, Milan.

François Morellet,
Sphère-trames,
1962.

Julio Le Parc,
Continual Instabili
I, 1962.

Claes Oldenburg,
Oven with Food,
1962. Neue Galerie,
Sammlung Ludwig,
Aachen.

Andy Warhol,
*200 Campbell's
Soup Cans*, 1962.
Private collection,
New York.

Roy Lichtenstein,
As I Opened Fire,
1964. Stedelijk
Museum,
Amsterdam.

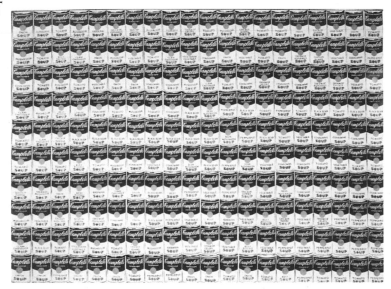

The natural landscape was substituted by an artificial urban one, and the gaze of the two artists was fixed on this "other" nature, that of the city, on its objects, its imagery, its relics, and they tried to grasp its vital impulses in order to give life back to them through the aesthetic operation. The works of Rauschenberg and Johns, and in part also those of Jim Dine, attempted to redeem the already consumed object from its scrap state in order to produce an artwork that exploited the last dregs of energy those objects contained in order to construct a new form. This was particularly true of Rauschenberg and his "combine paintings" (integrated paintings was the term the artist started to use in 1952 to describe his works), in which the most disparate elements were assembled in an operation that was clearly of Dadaist derivation (in addition to Duchamp's ready-mades, Schwitters' *Merz* also comes to mind), yet different from Dada in its attitude towards the object. While the Dadaists gathered and assembled found objects more or less casually, the Neo-Dadaists regarded civilisation's junk as part of the daily landscape, belonging to the life of the artist as they did to any other man, and they combined them logically and with a compositional expertise that came from a thorough knowledge of the history of artistic forms.

Rauschenberg's work also had strong ties to Abstract Expressionism, it was a homage almost to action painting and Pollock. In fact, the colour he dripped on the objects became a fundamental element for him, the binder between the various objects that went to make up the work. In the very moment the colour touched the different elements, it involved and incorporated them into the artistic problem. In *Monogram*, 1955-1959, Rauschenberg took a stuffed billy-goat, placed an automobile tire around its neck, and set it on a wooden base, a kind of platform, "binding" it all with gestural brushwork and drippings of colour. Colour thus became the binder that kept all the heterogeneous objects together; they were united even in their diversity into the single structure of the artwork.

On analysing the American artist's output, one is immediately struck by his remarkable compositional capacity, his ability to assemble materials according to rhythms and relationships that had nothing to do with chance. His works, thought out and constructed according to specific rules, had nothing to do with the haphazard mounds of objects that were to be found in dumps or warehouses, on the contrary, they were the history of artistic forms. Unlike the Dadaists' works, those of Rauschenberg showed how art could draw on a mass of rejected objects and redeem them through a knowledgeable and mas-

terly construction of a form, a form that competed with traditional works of art as much as it did with the products of industrial civilisation. In this regard, the artist remarked: "I followed my own method. If I couldn't find anything after going around the block, I went around another one. But that was all. The works had to seem at least as interesting as what was happening outside the window." Jasper Johns, on the other hand, worked in a more systematic, at times almost didactic, fashion. He took his distance from the object in order to grasp all its ambiguities and allusions. While Rauschenberg's works are extroverted and speak as they constantly launch signals, those of Johns are closed, concise, and turn inwardly as they explore the semantic significance of the single objects and imagery surrounding us. Targets, printed letters and numbers, flags, and fragments of human anatomy were, between 1955 and 1960, the subjects that the artist confronted using the ancient and precious pictorial technique of encaustic. Works like *White Flag* or *Target with Plaster Casts*, both of 1955, were examples of how the artist took simple, mundane images, analysed them and removed them from the insignificance of the quotidian in order to draw attention to them and increase their value through the pictorial technique. The white flag, painted with such extraordinary virtuosity, and the target, were established, conventional signs which the artist removed from common places surrounding them in order to show how they could become a pure pictorial sign in the artwork.

A world of junk, trash, and outdated objects also seemed to populate the works of other American and European artists. The American, Louise Nevelson, included pieces of unusable furniture in her orderly wardrobe-like structures. The Italian, Ettore Colla, collected scrap iron in order to create works that re-qualified those discarded elements once they had been removed from their logical industrial use by means of the aesthetic operation. Perhaps theirs was not the Neo-Dada of Rauschenberg and Johns in the strict sense of the word, but those artists did share the same desire to construct a language that would give the junk of the real world a voice in the world of artistic forms.

Nouveau Réalisme

In October 1961, the *Manifesto del nouveau réalisme* was published in Milan marking the official beginning of the movement that had been founded a short time before in Paris. In the docu-

ment was reiterated the need, common to many artists at that time (as was the case of the American Neo-Dadaists), to relate the world of art to the world of everyday life, and the artistic form to the used form. Once again art had to deal with reality and make use of its materials by incorporating them into its works. A torn poster or a pile of junk were thus turned into the instruments of a language that was constantly relating art and reality.

In the late 1950s, there was a revival of avant-garde activity in Paris, in particular of Dadaist derivation, especially among a group of artists who, co-ordinated by the critic Pierre Restany, founded Nouveau Réalisme. Instrumental in their research were the works of Yves Klein who, after the *Monochromes* of the 1950s which he himself labeled with the letters IKB (International Klein Blue), had undertaken a more articulated path inspired by Oriental philosophy by which he intended to produce an art made of absolute actions. In October 1960, on the occasion of an exhibition of the group at the Galleria Apollinaire in Milan, the *Manifesto del nouveau réalisme* was published. Restany declared in the text: "that sociology come to the aid of conscience and chance, whether it was a matter of the choosing or the ripping up of a poster, the character of an object, the dustbin or the residues of a room, the raging of mechanical affectivity, or the diffusion of sensation beyond the limits of its perception."

The works of Raymond Hains, Yves Klein, Arman, César, Daniel Spoerri, François Dufrène, Niki de Saint-Phalle, Martial Raysse, Christo, Gérard Deschamps, Jean Tinguely and Mimmo Rotella (the only Italian in the group), confirmed the declarations contained in the manifesto. Through their actions and works, they underscored a need for the artist to be present and active in the contemporary world in order to give rise to pluralistic aesthetic phenomena that were heterogeneous yet always international.

No longer was the artist one who possessed technical knowledge; on the contrary, he was one who made use of all the techniques, all the imagery and all the objects produced by the modern world. "These new realists consider the world to be like a picture, a great fundamental work from which they can appropriate certain fragments endowed with universal significance. They show us reality in the diverse aspects of its expressive totality. That which is manifested through the treatment of that objective imagery is the inner reality, the common good of human activity, the nature of the XX century,

industrial, advertising and urban technology," Restany pointed out. Therefore the most disparate materials were adopted: advertisements, movie posters, fluorescent lights, coloured plastic surfaces, leftover food, scrap iron or similar materials, in order to give life to the work, which was understood as being an aesthetic event that was placed in the same structure as reality. Like Dada first, and Neo-Dada later, Nouveau Réalisme departed from the real and confronted it in a continuous exchange of materials and sensations. The "décollages" of Rotella and Hains, Arman's *poubelles* (dustbins), Spoerri's tables with leftover food, Christo's wrappings, Tinguely's machines, and César's plastic structures were all an attempt to give life, by means of the aesthetic gesture, to the junk of industrial culture which was doomed to be eliminated when it was no longer useful. The artists collected everything that industrial technology left at their disposal in order to revitalise those signs and objects which, although then useless junk, were reactivated in the artwork.

The latter thus emerged as an object created by a masterful tinker, in which each element, assembled and interacting with the others, began to function according to the logic of art. Assemblage, accumulation, stratification and conservation were part of the new language, and the artist, much like a primitive, encountered the real world in order to make use of it in all its forms and materials.

A further development of Nouveau Réalisme led to "mec" or mechanical art, based on the theories of Pierre Restany in the mid-1960s, and adhered to by Rotella, Gianni Bertini, Bruno Di Bello, Alain Jacquet, Nikos, Elio Mariani and others. This new current stressed the need for art to turn to the techniques of its own time, producing works that foresaw the employment of typography, photographic material and the assemblage of media images.

Op Art

The term "Op Art" (Optical Art) refers to the movement composed of artists from Europe, the United States, and even South America, who, starting in the mid-1950s, tried to establish a new artistic language by using scientific ideas and instruments. The works of Vasarely, Alviani, Scheggi, Soto and Le Parc were executed according to the rules of visual perception, that is, the faculty to think by means of static or dynamic images. They in fact initially started to work by employing simple elements like geometric forms and primary colours, and went on to create more

complex pictorial planes that suggested movement by means of scientifically constructed visual patterns and numerous optical illusions.

The mid-1950s were characterised by researches of a visual-kinetic character that took their lead from scientific treatises. Active in the group were Victor Vasarely, Getulio Alviani, Paolo Scheggi, Jesus Raphael Soto, Yacov Agam, Bridget Riley, Julio Le Parc and Carlo Cruz-Diez. Undoubtedly, the works of the Hungarian Laszló Moholy-Nagy, who was formed in the ambit of Constructivism and later was active at the Bauhaus, and another artist and professor of the Weimar school, Josef Albers, were extremely instrumental for the young artists who were exploring visual problems. Although they shared the two avant-garde masters' main ideas, based on the perceptive processes and their relationship to the subjectivity of vision, the optical artists based their own research on two fundamental points: 1) since the individual was conditioned by prior experiences which could not be removed, he had to be freed from his own perceptive faculties; 2) perception represented a part or a moment in the imagination which was to be interpreted as the activity of thinking through initially static and subsequently dynamic images.

Thus the deduction that research could not be resolved in one single image, but rather in a sequence of images determined by a rhythm, and that the capacity of such images to become associated could only occur in the sequence itself, or in the viewer or externally to him, when it was determined by optical or luminous mechanisms. An extreme scientific rigour, the use of simple or complex geometric elements, and a profound knowledge of the theories of colour and visual perception underpinned the Op Art researches. While close to the figure of the scientist, these artists were, however, able to implement their scientific results in an aesthetic manner. By means of relatively simple black and white geometric figures, optical effects were initially created in which the definition of the form was precise and explicit. Subsequently, the laws of colour theories were exploited (simultaneous contrasts, decreasing or increasing tonal scales, etc.) as well as those of form with particular attention paid to *Gestalt* research.

By departing from those simple elements, the artists started to move the plane according to a freer formal logic so as to create a suggestion of relief on the flat surface of the painting due to optical effects or the insertion of three-dimensional elements.

In 1965, the results of Op Art were presented at the Museum of Modern Art in New York in a huge exhibition entitled "The Responsive Eye." The public was fascinated by the infinite optical illusions created by the artworks and grasped the beauty of such work inasmuch as it was an aesthetic operation that had been achieved through the use of science. The conventional rules of perception were all called into question and subverted in order to demonstrate how a totally immobile plane could be made to move by using elements of a perceptive nature only.

Vasarely, in particular, defined and exaggerated such elements, creating pictorial surfaces in which the movements that the forms and colours created were visually discomforting, whereas others, like Alvani, gave greater emphasis to elements of a technological nature. By the use of non-pictorial materials there was an attempt to relate form and material in order to underline the visual perception that derived from it.

Kinetic and Programmed Art

The New Tendency Movement founded in Zagreb in 1961 united artists and international groups who were carrying out parallel researches, identified by the terms kinetic and programmed art. What characterised the work of artists like Colombo, Morellet, Le Parc and others, was the specific attention paid to modern technologies and perceptive phenomena of optical derivation. By using materials and industrially-produced machinery, they intended to construct a new language which would result in the creation of the artwork, not only from the aesthetic value of the materials employed, but also from the interaction between the construction and the spectator, in which the spectator became the determining element for the existence of the work itself.

That kinetic and programmed art were connected to some Op Art researches is without question, although they were differences between them. During the late 1950s, some European and South American artists converged in their research and came forth with a new language in which elements that were limited to design were embodied in the artwork and in some cases became models that were also used in design and industrial projects.

In 1961, in Zagreb, the Brazilian painter Almir Mavignier, the Serbian critic Marko Mestrovich, and the director of the Zagreb Gallery of

Contemporary Art, the Croatian Bozo Bek, collaborated to form the New Tendency movement. In order to sanction the birth of that new area of research, an exhibition was organised in Zagreb to which were invited artists and groups, among whom the Italian Group T of Milan (Giovanni Anceschi, Davide Boriani, Gianni Colombo, Gabriele De Vecchi and Grazia Varisco), Group N of Padua (Manfredo Massironi, Alberto Biasi, Ennio Chiggio, Toni Costa and Edoardo Landi), the GRAV (Groupe de recherche d'art visuel) of Paris (François Morellet, Julio Le Parc, Joël Stein, Jean-Pierre Yvaral, Horacio Garcia Rossi, and Francisco Sobrino), plus some individual artists, Le Parc, Morellet, von Graevenitz, Sobrino, Stein, Alviani, Mack among others.

Working along the same lines of research as these artists were those of the Research Group which had been formed a few years earlier (Enzo Mari, Umberto Eco and Bruno Munari) who, together with other artists like Enrico Castellani, Dadamaino and Piero Manzoni, had already started to experiment with perceptive and kinetic theories in the Azimut exhibition space which Manzoni and Castellani had opened in Milan between 1959 and 1960 together with Agostino Bonalumi. They were subsequently joined by the Gruppo Uno (Group One) of Rome (Gastone Biggio, Nicola Carrino, Nato Frascà, Achille Pace, Pasquale Santoro, Giuseppe Uncini who were backed by the critic Giulio Carlo Argan), and the Gruppo Zero of Düsseldorf (Heinz Mack, Otto Piene, and Günther Uecker), which Lucio Fontana, Yves Klein and others were close to for a certain period.

The kinetic artists' work was based on a scientific analysis of all the perceptive phenomena in order to reach a form of expression that was closely connected to science, industrial techniques and the new technologies. The premise of the work was the project, as it was in industrial production, and its capacity to be inserted into the social context in order to influence and modify it. A position, therefore, of avant-garde derivation. Through the use of materials, machinery and industrial structures, the "kinetic and programmed" artists tried to find connections with the aesthetic world. Materials were considered and used because of their innovative capacity not only on the level of producing objects and goods, but chiefly because of their formal and aesthetic qualities. The artwork was the end result of a project that took into consideration technical, material and environmental factors, one that implied a relationship with the viewer, who was no longer to be a mere user but the element that now determined the life of the artwork.

Many works opened towards the viewer, who could make them function by participating actively (by pressing buttons, introducing air, or

pushing levers, etc. to start the machinery). The kinetic artwork was open to reality, from which it utilised materials, and procedures of execution and fruition by departing from a scientifically based analysis, the finality of which, however, was not the creation of purely technical and mechanical forms, but rather the creation of a mechanism-artwork that was available for an infinite variety of real or imaginary uses.

Pop Art

Pop Art was an artistic movement that first made its appearance in England in the works of Hamilton and Paolozzi and in the theories of Alloway. In 1952-1953, together with the Independent Group, they initiated an international debate regarding society and contemporary culture as related to technology and the mass media.
Pop Art was then picked up and developed in the United States through the works of Warhol, Lichtenstein, Dine, Oldenburg, Wesselmann, Rivers, Segal, Rosenquist, and others, and subsequently spread throughout Europe. Starting from a reflection about the contemporary world, characterised by an abundance of consumer products and the increasingly massive presence of the media, the Pop artists took their materials, imagery or objects, from that context, that is, from reality. Rather than defend or demonise those consumer products, they chose to make use of them in their artworks. Pop art was open to all forms of communication and popular information in its attempt to embody all of reality in its own language. The images of Coca-Cola or Marilyn Monroe, like Dick Tracy comic strips or hamburgers, on walls, in advertisements, comic books, or food shops made their way into museums in infinite reproductions through the repetition of an artistic technique.

Pop Art in the United States

Not even European culture could remain extraneous to the art that was considered the most authentically American, Pop Art. The matrices of this movement, so representative of the United States in all its cultural and popular aspects, were to be found in the historical avant-garde movements, in particular in Duchamp's ready-mades. While the object was considered from a viewpoint of the concreteness of the form in the ready-made, the American Pop artists, on the contrary, made use of the ready-made image, since more than in the object itself they were interested in the way it was communi-

cated by means of a sign or an "advertisement." That image, one of the infinite repertoire of images populating the city, underlined the non-creativity of the world more than its creativity. The early 1960s in America, and in part also in Europe, were characterised by the massive invasion of an enormous quantity of consumer goods and advertisements of them in everyday life. It was in that world that man was forced to live, a world in which the notion of culture, that is, the result of human intervention, substituted that of nature. The cyclic balance of nature was replaced by the congested rhythm of the city, its products and its media. The artist who operated in such a context took his materials, conceptual or concrete, from a warehouse of goods, images and sensations that had crossed through industrial production and the media.

As in the case of the Neo-Dadaists, Rauschenberg and Johns, the materials to be found in the city represented an inexhaustible source of inspiration.

The Pop art movement (Pop was an abbreviation for Popular Art) originated with the Independent Group of London (1952-1953), formed by the artists Richard Hamilton and Eduardo Paolozzi, the architects James Stirling and John Voelcker, some photographers, the critic Lawrence Alloway, and later by Richard Smith. The group organised meetings and conferences on technology, cybernetics, the aesthetics of the machine, and popular music in order to find aesthetic contents in the instruments of mass communication and the new technologies.

Starting in the early 1960s, the young American artists, Claes Oldenburg, Jim Dine, James Rosenquist, Roy Lichtenstein, Andy Warhol, George Segal, Tom Wesselmann, John Chamberlain, Robert Watts, Larry Rivers, Robert Indiana, Mel Ramos and others, developed a strong interest in what was surrounding them, especially since the city of New York was rich in materials and imagery that were available for use. Thus Rauschenberg incorporated a stuffed billy-goat into his work, while Warhol made use of Coca-Cola and Campbell's Soup advertisements because they were part of his landscape, his real world. In his works, the three-dimensional object was substituted by its dazzling advertising image, it lost its value as a useful object in order to make way for its serigraph reproduction that was cooler and more seductive because of the technological rendering. The language of Pop art was open to all forms of popular communication like comics, advertising, slick magazines, and supermarkets where goods were not judged for their intrinsic qualities as much as they were for the se-

ductive power they exuded through packaging and graphics. Brillo soap-pads were of interest to Warhol not because of their detergent quality but because of the "beauty" of their package, in the same way that Marilyn did not attract because of her femininity or acting talents but because she was a myth-sign in the popular imagination.

America was an inexhaustible treasure chest of materials for Pop artists. Coca-Cola bottles and Jacqueline Kennedy, Dick Tracy comics and the atom bomb mushroom, the electric chair and hamburgers, they all existed on the same plane, and there was no distinction between good and evil or beautiful and ugly. Pop art did not judge, anything and everything could function and participate in making art.

The techniques employed also reflected the modern production processes perfectly: images were produced by serigraph, screening, or mechanically assembled, or, in the case of objects, reproduced in plaster or brightly coloured resins. All of reality entered into the aesthetic process, everything was equal to everything else, as in some huge supermarket where one was constantly seduced by the quantity of goods and their alluring advertising images.

Pop Art in Europe

Pop Art became known to the European art world immediately, primarily through the Venice Biennale of 1964 which gave it a spectacular presentation, and awarded the first prize to Robert Rauschenberg, who was considered the precursor of Pop art.

Many European artists responded to its language, adopting some of its features in different ways, and finding their own identity with respect to the Americans. The Italians included the so-called Piazza del Popolo School in Rome with Tano Festa, Franco Angeli, Mario Schifano, Mario Ceroli, Fabio Mauri, Giosetta Fioroni, Jannis Kounellis; the Milanese, Valerio Adami, Emilio Tadini, Alik Cavaliere, Lucio Del Pezzo; as well as Titina Maselli, Pino Pascali, Claudio Cintoli, Beppe Devalle, Concetto Pozzati, Umberto Buscioni, Renato Mambor, Ugo Nespolo, Sergio Lombardi, Aldo Mondino, Piero Gilardi, Michelangelo Pistoletto; and, in part also Enrico Baj and Domenico Gnoli. They all elaborated a language that absorbed the more humanistic and literary values of Pop art, one that reflected their different cultural autonomies and individual sensitivities. Proposing viewpoints that were original and heterogeneous, in some cases even critical towards American Pop, they created a climate in which the influences coming from the other side of the ocean were filtered with a

sense of irony through past and present history, culture and memory. The English artists, David Hockney, Richard Hamilton, Joe Tilson, Patrick Caulfield, Eduardo Paolozzi, Peter Blake, Ronald B. Kitaj, Allen Jones, and Peter Phillips interpreted the new mythologies by reviving a representational art that was historically grounded and absorbed, and by observing the mass media from an ironic point of view.

The French Martial Raysse, Hervé Télémaque, Alain Jacquet, Bernard Rancillac, and Jacques Monory took their imagery from a vast repertoire of everyday life that ranged from cosmetic advertisements and comic strips to a psychological analysis of the urban context, whereas the Germans, Peter Klasen, who was working in Paris, and Winfred Gaul constructed images of strong intensity. In Stockholm, Oyvind Fahlström absorbed some of the elements of Pop art placing different images from the comic strip world in a continuous relationship thus constructing a narrative layout that was open to a variety of readings.

The different figurative-Pop styles that developed in Europe around the mid-1960s were alike in the fact that they did not adopt the cold figuration that was so typical of Pop art and rightly considered the fruit of an ideology of capitalistic stamp. What the artists were trying to find was a greater continuity with tradition in their painting, according to their individual countries cultures, as well as a greater commitment to human and social issues.

Operating along those lines was the Zebra group, composed of Dieter Asmus, Peter Nagel, Nikolaus Stortenbecker and Dietmar Ulrich, which was formed in Hamburg in 1964. They reacted against *art informel* and returned to the pictorial and social sensitivity of New Objectivity, producing a cold, synthetic figuration that took its inspiration from news photographs.

The French movement of Nouvelle Figuration and that of Nuova Figurazione Italiana, although associated in name, also remained autonomous in their researches which were characterised by a strong social commitment and, while not rejecting a cold iconography of technological matrix, produced paintings that were deeply committed and oriented towards man and his problems rather than to his products and images.

Among the many artists who adhered to these groups were: Eduardo Arroyo, Gianni Bertini, Leonardo Cremonini, Antonio Recalcati, Paolo Baratella, Fernando De Filippi, Giangiacomo Spadari, Piero Guccione, Attilio Forgioli, Giancarlo Ossola, and Umberto Mariani.

Visual Poetry

In the early 1960s, some artists started to explore the connection between words and images, thus giving rise to the movement that became known as Visual Poetry. Included within this formula were all those researches that by placing the two term of word and image in the same context, investigated the possibilities these assumed in such a relationship. The pictorial plane therefore became the place where the word sign and the image-sign could interact.

Words and images have long been closely connected in pictorial works, and when utilised as the signified or as a mere signifier have been present in twentieth-century art since the time of the Cubist movement. In the beginning of the 1960s, a group of Florentine artists, Giuseppe Chiari, Eugenio Miccini, Lamberto Pignotti, Luciano Ori, Lucia Marcucci, and Ketty La Rocca, together with Emilio Isgrò, Sarenco, Anna and Martino Oberto, Magdalo Mussio, Ugo Carrega, Roberto Sanesi, Adriano Spatola, Vincenzo Ferrari, Gianfranco Baruchello, William Xerra, Vincenzo Accame and others—whom Cy Twombley and Gastone Novelli had already anticipated in 1958 with paintings in which the word-sign took on a pictorial-formal value—produced works in which the two elements in question, the words and the images, were embodied in the structure of the artwork. At the same time, some foreign artists who were dealing with the same problems elaborated the possibility of a poetic text becoming the word-sign. Jiří Kolár, Augusto and Haroldo de Campos, José Grunewald, Eugen Gomringer and many others contributed to the international movement known as Visual Poetry. Included in it were researches deriving partly from Fluxus, from concrete poetry (Oyvind Fahlström had already in 1952 drawn up the *Manifesto of Concrete Poetry* in which he emphasised not only the linguistic but also the aesthetic-formal value of the poetic structure), from some aspects of Conceptualism, and in particular from Lettrist research.

The literary-artistic Lettrist movement, founded in Paris in 1946 by Isidore Isou, borrowed from Dadaist and Surrealist experimentation, and maintained that painting had to once again become an instrument of universal communication. By making use of signs and letters, it attempted to construct a grammar in which all the arts could converge.

The authors of visual poetry approached the problem and its subsequent solution in their works differently: some emphasised the conceptual aspects, others visualised the poetic writing graphically, while still others tried to integrate the verbal elements and graphic signs in the artwork in a formal equilibrium. Artists like Ilse and Pierre Garnier, Henri Chopin, François Dufrène, Dieter Roth, Arrigo Lora Totino, Max Bense and others also explored and experimented aspects of phonetic character, which research took the name of phonetic poetry.

Researches similar to the visual poetry experiments resulted in mail art which started in 1962 when Ray Johnson established the New York Correspondence School of Art. Many artists throughout the world adhered to mail art, the objective of which was to put artists and common people world-wide in communication so that they would be able to publicise their own work outside of the art world's commercial structures and traditional sites: it was a way of communicating freely in which words, signs, texts and colours became the tools for a direct and immediate interaction.

Minimal Art

Minimal Art, which appeared in the United States in the early 1970s almost contemporaneously to Pop Art, based its research on the concept of a "reduction" and "cooling" of the artwork. It counteracted the exuberant opulence of urban forms, the media, and advertising with formal solutions that adopted elemental geometric forms and natural and industrial materials. By reducing the formal and chromatic impact to a minimum, the Minimal artists produced rigorous works that were meant to be inserted in the everyday world, and contrast the din of the latter with the silence of the project.

In the beginning of the 1970s, the two types of research underway in the United States seemed to be working in opposite directions. Pop Art was all image and colour, while Minimal Art was a total reduction of image and colour. In reality, what these two movements did have in common was their work on the "cooling" of the image. Pop Art went even further and cooled everyday imagery through serial reproductions, whereas Minimal Art reduced the formal and chromatic impact of real forms to a minimum by means of elemental geometric forms and neutral colours, or by the choice of

materials that would not be confused with the hyper-coloured, hyper-decorated ones of the metropolis.

An anticipation of Minimal research could already be seen in the reduction of the forms and colours in the works of Frank Stella, Robert Ryman, Brice Marden, Robert Mangold and Richard Tuttle, and even before in those of Agnes Martin and Ad Reinhardt. For those artists, the pictorial plane became a space where the form-colour was self-referential, the plane did not refer to a reality outside of the work but to the plane itself and its own problems. But the Minimal Art group—the term was invented by the critic Richard Wollheim in 1965—was composed primarily of Americans, Donald Judd, Robert Morris, Carl Andre, Dan Flavin, Sol LeWitt, Tony Smith, Walter De Maria, and the British Anthony Caro, William Tucker and Philip King. Their intent was to create works in which there was a total synthesis between form-volume and colour, and where such a synthesis could then be inserted into the polymorphic and polychromatic urban environment without altering the force of its immaculate neatness. The three-dimensional works that they constructed maintained the ideas of space, geometry and order. They were constructions executed on an elementary yet rigorous geometric plan in which the space was created by the open and closed areas of an artwork that made use of simple modular elements and was based on regular rhythms, divisions and equilibriums.

Attentive to technology, the Minimalists made use of some its materials, however, not to exalt their emotional potential but rather to show the possibility of their becoming aesthetic elements. They wanted to demonstrate the artist's capacity to exploit industrially produced conceptual elements, like that of the project being an idea and procedure of the artwork, or the materials (metal bars or wires, felt cloths, fluorescent lights) in order to come up with a new aesthetic language, following the crisis of painting, sculpture and architecture, in which such elements reflected the totally constructed, artificial real world. In contrast with the uproar of the city and the chaotic proliferation of signs and chromatic noise that characterised it, they offered the silence of meditation, the rigour of the project, the immaculacy of form, the essentiality of the materials, and the neutrality of colour.

The aesthetic theory they elaborated was unencumbered and free to penetrate the minimal language of art with rules and order. Minimal, essential, attentive to its own inner rhythm, its own construc-

tive tension, unconcerned about the observer, the only thing it asked of the artwork was to be pleasing to the eye: these were the characteristics of Minimal Art. The pleasure it offered was intellectual more than visual, and the objective, almost classical beauty of its forms derived from rigorous constructive parameters, the essentiality and truth of which were to be found in the intellectuality of the project more than in its emotionality.

Some Minimalist and analytical researches were picked up in Europe at the end of the 1960s and the beginning of the 1970s. In France in particular, the Support-Surface group, formed of artists from Nice and Paris, among whom, Louis Cane, Daniel Dezeuze, Claude Viallat, Vincent Bioulès, Marc Devade, and the BMPT group, which was formed in 1967 and included Daniel Buren, Olivier Mosset, Michel Parmentier and Niele Toroni, interpreted painting as a work of self-reflection which investigated its own elements, reducing its materials to the minimum, deconstructing them.

In Italy, some artists like Rodolfo Aricò, Gianfranco Pardi, Giuseppe Uncini, Mauro Staccioli, Nicola Carrino, Livio Marzot, and Massimo Mochetti showed more interest in the structural elements, whereas Claudio Verna, Claudio Olivieri, Giorgio Griffa, Carmengloria Morales and Antonio Passa concentrated on the pictorial plane.

All of them, however, preceded by Francesco Lo Savio, whose work was closer to Mondrian and Malevich than to the American minimalists, worked on the idea of art as a "visual project." By their use of materials, forms, and basic primary colours, their work became a meditation on art as well as on reality, as it related the forms of art to the world of modern forms.

Land Art

In the second half of the 1960s the land art movement began in the United States. Unlike Minimalism which attempted to confront the artificial forms of the city, land art sought contact with the natural, uncontaminated places characterising America. While it derived from Minimalism on a strictly formal plane, land art was distinguished by its strong emotional quality, its use of natural materials, and its confrontation with the geology of the territory, thus allowing culture and nature, the art form and the natural form, to interact and be resolved in the artwork.

While Minimal Art was committed to dealing with the metropolitan reality and its structure, the exponents of land art sought an exchange and confrontation with another aspect of American reality, the uncontaminated nature of its prairies, canyons, salt lakes, Rocky Mountains, and endless deserts. Michael Heizer, one of the major representatives of the movement, wrote: "You can find that kind of untouched, peaceful, religious space in the desert that artists have always tried to put into their work." For his first work, created in the autumn of 1967, he convinced a New York collector to provide him with the financial and material means necessary for its execution: he flew over the Nevada desert looking for a suitable place to make an excavation that was fifteen metres deep and more than half a kilometre long. Other works followed, like *Circular Surface Planar Displacement*, where he "drew" gigantic circles following the tracks made by the wheels of a motorcycle.

Other land artists were Walter De Maria, Robert Smithson, Richard Serra, Dennis Oppenheim, and the Europeans, Richard Long, Barry Flanagan, and later the Bulgarian, Christo.

The term "land art" was first used by the Germany gallery owner, Gerry Schum, as the title for a videocassette that he himself had made documenting the works executed by some of the above-mentioned artists, which had also been presented in an exhibition entitled "Earth Works", organised by Robert Smithson, and inaugurated at the Dawn Gallery in New York in 1968.

In placing their sculptures in the desert or the Rocky Mountains, and in their use of the different elements that nature had to offer as instruments for the execution of their artworks, the land artists were trying to establish a relationship with nature, a more intimate rapport with the environment. Their works were formally of a rigorous Minimalism, indeed, many of the artists had originally been part of that movement, and they adopted circles, spirals, cubes, parallelepipeds, and other simple geometric forms to express its language. What distinguished the land art movement were factors of an emotional or emotive nature, a relationship with the shape of the land and its materials, and social and ideological elements. Important for land art were those socially sensitive issues that had emerged in the new reality and the new models of life throughout the world at that time.

Those were, in fact, the years of a cultural and social "revolution", and of the protest against the middle-class industrial system that suffocated the individual, forcing him to survive in a space—the

Richard Hamilton,
*Just What Is It that
Makes Today's
Homes So Different,
So Appealing*, 1956.
Kunsthalle,
Tübingen.

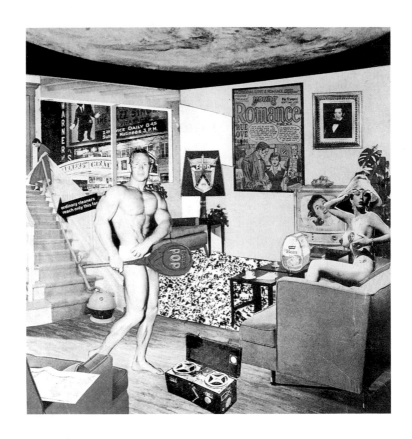

Hervé Télémaque,
Breeze, 1965.
Françoise and Jean
Levantès collection,
Nice.

Peter Blake,
Bo Diddley, 1963.
Private collection.

L

Mario Schifano,
Futurism Revisited,
1966. Giorgio
Marconi collection,
Milan.

Valerio Adami,
*Henri Matisse
Drawing in a
Sketchbook*, 1956.
Galleria Giò
Marconi, Milan.

Michelangelo
Pistoletto, *The Dog
with His Tail Down*,
1969. Galleria Giò
Marconi, Milan.

Enrico Baj,
General, 1961.
Galleria Giò
Marconi, Milan.

Emilio Tadini,
Color & Co., 1969.
Giorgio Marconi
collection, Milan.

Carl Andre,
A-Void, B-Void,
C-Void, 1972.

Dan Flavin,
Monument for V.
Tatlin, 1966-1969
and 1968-1969.

Donald Judd,
Untitled, 1973.

Michael Heizer,
*Circular Surface
Planar
Displacement,* 1970.

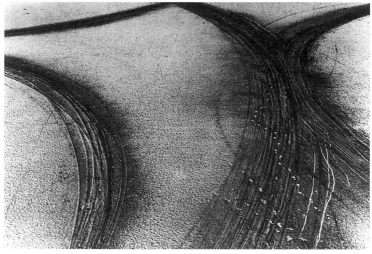

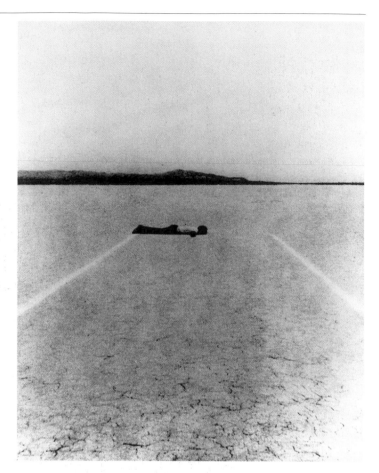

Walter De Maria,
*The Lines, Three
Circles, The Desert,*
1969.

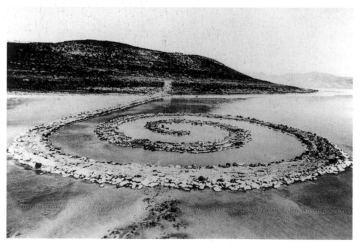

Robert Smithson,
Spiral Jetty, 1970.

Joseph Kosuth,
*One and Three
Chairs*, 1965-1966.

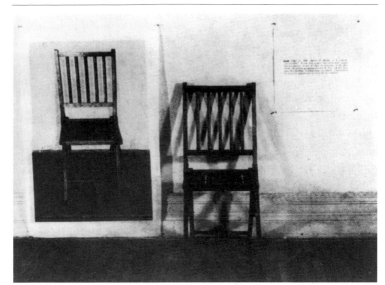

Giulio Paolini,
Averroès, 1967.
Galleria Giò
Marconi, Milan.

Sol LeWitt,
Untitled, 1965.
Private collection,
Milan.

annis Kounellis,
orses, 1969.
alleria L'Attico,
ome.

Mario Merz,
Nature and The Art
of The Number,
976.

Vito Acconci,
Reception Room,
1973.

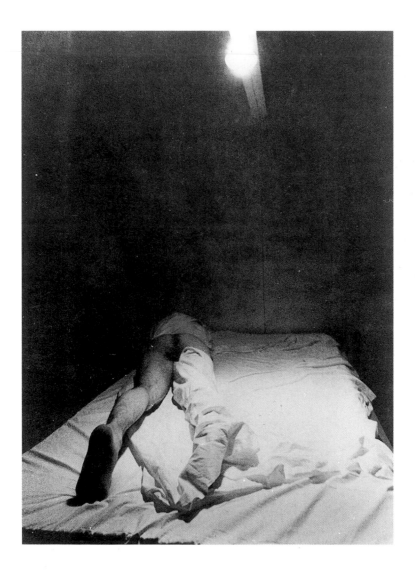

Arnulf Rainer,
Korpensprache,
1971.

Arnulf Rainer,
Poses, 1972.

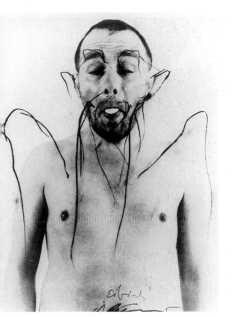 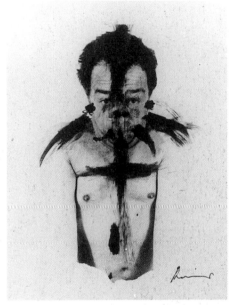

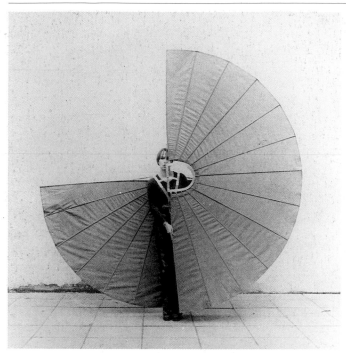

Rebecca Horn,
Fan, 1974.

Urs Lüthi,
Untitled, 1974.

Luigi Ontani,
Adam/Eve, 1974.

Gilbert & George,
The Red Sculpture,
1976.

Frank Gertsch,
Medici, 1971-1977.
Museum Moderner
Kunst, Vienna.

city or the factory—that dampened any creative impulse and any sense of liberty. Many abandoned the cities, choosing, with an almost romantic gesture, to go back to the land, to nature, where there was something different from themselves to confront, and where they felt the free, creative gesture was still possible.

The need to find new places far from museums and galleries in order to create artworks that were free from any commercial, political or social conditioning spurred those artists to seek new spaces in which the authenticity, the freedom and truth of art and existence could be achieved. American art, Pop Art in particular with its cold imagery, and Minimal Art with its severe industrially fabricated works, had not provided satisfactory answers, according to the land artists, to the infinite questions posed by the artist. For them, art had to be open to all the flows of existence, to all the sensations and materials in the world, to a total involvement with the forms and experiences of reality.

They did not augur a return to a naturalism that no longer existed, but were simply seeking an artistic language in which nature could provide the artwork with a structure that readily incorporated those mechanical and industrial materials (like the digging machinery, bulldozers, lorries or motorcycles) that made it technically possible. The natural and artificial worlds confronted one another and engaged in a dialogue that produced an aesthetic event that became a continuous flow of sensations, emotions and existence. Such themes would later be picked up in other researches, like art in nature, in which ecological issues and the defence of the environment were of paramount importance.

Conceptual Art

The term refers to the research that American and British artists developed during the second half of the 1960s primarily. Based on their studies of the philosophy of language and structuralism, the Conceptualists analysed reality in order to create an art that could be defined conceptually and linguistically. The total autonomy of the language of art with respect to any perceptible form was underscored in the declaration of the American artist, Joseph Kosuth, "art is the definition of art": art is art and refers only to itself and its own language.

The definition "Conceptual Art", a term that first appeared in

1967 in a text by Sol LeWitt entitled *Paragraphs on Conceptual Art*, was applied to a specific movement that formed during the mid-1960s, and which included Joseph Kosuth, the British group Art & Language (founded in 1968 by Terry Atkinson, David Bainbridge, Michael Baldwin, and Harold Hurrel), and Victor Burgin, Bernar Venet, Jan Burn, and Mel Ramsden, and was promoted by the French critic Catherine Millet. By using instruments that derived from the philosophy of language and structuralism, they explored the actual definition of the artistic operation and empirical reality in order to find its basis. The term "conceptual" can be attributed to a variety of situations in modern art (from the definition of the "painter-philosopher" formulated by the Neo-classic Anton Raphael Mengs to Duchamp's ready-mades), but the Conceptualism of the new generation of artists referred to other definitions, like that, for example, of Ad Reinhardt who, in 1961, in reference to painting, declared: "What you can say about art is it is art. Art is art and everything else. Art like art is nothing but art. What is not art is not art."

In the text *Art after Philosophy*, published in 1969, Kosuth stated that "the only vindication of art is art. Art is the definition of art", and "art as idea as idea", which was like saying that the only possibility left to art was that of being the subject and object of its own language. Sol LeWitt, in turn, in his text of 1967, said that "the idea in itself, even if it isn't achieved visually, is a work of art as much as the finished product is." By idea, he simply meant the project which was of Minimal derivation, and according to him conceptually determined the truth of the work. If art defined itself through its own process of conceptual analysis, it became a tautology, "art is art", in which the subject and predicate referred to one another without any need of further specifications of a formal or linguistic order. Art was, in brief, the very definition of art. In a series of works, *Investigations*, begun in 1965, Kosuth analysed some of the concepts regarding concrete, material elements (air, water, earth, etc.) and immaterial ones (time, idea, universal, art, etc.), and made photographic enlargements of their relative dictionary definitions. In more material works like *One and Three Chairs* of 1965-1966 he presented a real chair, a photograph of it, and a photographic enlargement of the dictionary definition of the word "chair": there was a continuous reference in the whole work to the three formally and technically different elements all of which answered to the single concept of chair.

While traditional art had wanted and known how to interpret real objects by using its own tools and according to the contents that the different aesthetics and poetics elaborated from time to time, and while it had already experimented with all the materials, means and techniques of representation, arriving at Reinhardt's "last painting that anyone could make", the only thing left for it to do now was interrogate itself about itself, its language, and its theoretical and material instruments in order to find a linguistic definition of itself as art.

No longer were there forms to represent or techniques to invent; the only thing left for art to do was investigate itself, to see if it could create a work-concept that could respond to the materiality and partiality of the world with the immateriality and universality of the idea. Many other artists throughout the world followed in their footsteps, and adopted a conceptual matrix in their own work: On Kawara, Hans Haacke, Douglas Huebler, Robert Barry, Lawrence Weiner, Ed Ruscha, Hanne Darboven, Dorothea Rockburn, Marcel Brookthaers, Vettor Pisani, Gino De Dominicis, Antonio Dias, Vincenzo Agnetti, Giulio Paolini, Claudio Parmiggiani, Antonio Trotta, Franco Vaccari, Luca Maria Patella, and Alighiero Boetti.

Arte Povera

The Arte Povera movement brought Italy into the centre of the international art world in the mid-1960s. Founded in Turin by a group of artists who came from all over Italy, and promoted by the critic Germano Celant, the movement was representative of what was happening internationally: art had opened up to a wide variety of materials, in particular natural ones. In contrast with the concept of representation, which had always constituted the basis for artistic research, the Arte Povera artists favoured the "directly experienced." They sought a language that would make it possible "to create a new relationship with the world of things", in particular with nature.

"Animals, vegetables and minerals have cropped up in the world of art", so wrote the critic Germano Celant in *Arte povera* (1969), which documented the works of artists belonging to the group he had founded. The movement originated in Turin in 1967 from the association between Germano Celant and Michelangelo Pistoletto,

Mario Merz, Jannis Kounellis, Luciano Fabro, Giovanni Anselmo, Pier Paolo Calzolari, Giulio Paolini, Alighiero Boetti, Giuseppe Penone, Gilberto Zorio and Emilio Prini, and which also included, although they were not in Celant's book, Piero Gilardi, Gianni Piacentino and Pino Pascali with some particular works of his.

Affined to the research of American land art, and in the theatrical field, to the "poor theatre" of the Polish director Jerzy Grotowsky, the Italian artists' investigation was aimed at a total osmosis with nature. Arte Povera shared the same need to become part of the natural context, whether it was concrete or conceptual, in order to behave "like a simple-structured organism", mingling with the environment and camouflaging itself in it so as to widen its perceptive and emotional threshold as much as possible "to create a new relationship with the world of things." What those artists wanted to discover was not only the nature outside of themselves, animal, vegetable or mineral, but also the nature inside themselves, their own bodies, memories, gestures, any element at all that was connected to the sphere of perceptive existence. The rapport between the artist and the world was not mediated, nor did it intend to re-elaborate the various materials that artists came into contact with; it was, on the contrary, a primary encounter and relationship between living beings and it created a new language from such elements and feelings. The artist "chooses what is directly experienced, no longer what is represented", which had already been the source of inspiration for the Pop artists, "aspire to live, not to see", and in that living or experiencing he discovered his own strength and that of the world which were the basis of the artwork.

The Arte Povera works transcended all the traditional art techniques, they moved out of the conventional space of representation, the museum or gallery, to search for a new, more authentic relationship with the world. Not only did the artist and the world interact in the artwork, but the viewer was also essential, since as the user of the aesthetic fact, he had to take an active part in the making of the artistic event.

Pistoletto invaded the city space, in particular with his *Zoo*, which was a sort of street theatre: "For me art and life are both a question of duration, I do not desire to make art die any more than I desire to make life die. The greatest art would be that of making life live forever." Such tension was also present in his mirror paintings which united the author and the spectator in the work, enhancing it with a new dimension every time.

The works of the Arte Povera artists were filled with everything: not

only sensitivity and emotionality, but also technology (Merz's neon
tubes), live animals (Kounellis's horses or parrot), dried branches,
trees, woods, and so on, defining a new language of art that contin-
ually and impartially related all the elements of existence and there-
fore of art in the final work.

Body Art

During the 1960s and 1970s, the use of the body as a "medium
of expression" gave rise to what was known as body art: the
body was no longer interpreted and represented by means of
the materials of art, but was used as a medium itself, as a sub-
ject and linguistic instrument. The exponents of body art went
beyond the concept of representation to experience the aesthet-
ic event directly and openly in first person. By using their bodies
in their performances they experimented with the basic impuls-
es motivating the lives of everyone in order to arrive at a degree
of authenticity that could only be reached in life.

Body art was an international phenomenon that developed between
the 1960s and 1970s and which was manifested with a certain vio-
lence in spectacular and provocative actions and performances. The
body artists were not interpreting characters or representing stories
when they used their bodies, they themselves were the characters
and they were living their stories in first person. Their actions were
presented in museums and galleries, in live performances, filmed in
video, or photographed. They wanted to involve the spectator in an
action that, although it was intimate and private, required the pres-
ence of another person in order to be understood and confirmed.
The spectator therefore became an accomplice in the event, partic-
ipating in it emotionally. Following their unconscious impulses and
urges, those artists lived through all kinds of experiences in first per-
son, passing from pleasure to pain in their search for the truth con-
cealed within each of us. By going through both everyday and ex-
ceptional experiences, the subject-artist tried to attain that degree of
truth that he seemed to have lost definitively.
From the unconscious emerged fantasies, repressed events, and un-
expressed and unsatisfied desires which took shape in actions, per-
formances or photographic images and which, by exploiting even
the most recondite, secret and private components of pleasure and
pain, could be liberated and revealed. The artists put on disguises,

changed sex formally in a sort of photographic metamorphosis, used their own voices, natural or taped, and their own gestures in order to show truth to the spectator in their spasmodic search for approval or a show of affection.

Lea Vergine, in her book *Il corpo come linguaggio*, published in 1974, wrote: "Man is obsessed by the need to show himself in order to be", and in this continual search for the other he made use of any instrument at his disposal, the first being his own body, and behaved like a baby that laughed or cried in order to attract its parents' attention and affection.

The exponents of body art, by their dressing up, disguising themselves, or even undressing, by their rejoicing or suffering, recovered every fragment of their existence as material to use because it was only through the authenticity of life that they could confront the materials of art and its language. Their performances were often violent, as in the case of the Viennese "actionists" (Wiener Aktionismus), Hermann Nitsch, Otto Muehl, Günther Brus, Rudolf Schwarzkogler, and Arnulf Rainer. Rainer took photographs in which his face and body appeared deformed, and subsequently disfigured those images even more with cancellations and black marks. A propos of his own works, Rainer said: "I don't consider them only a mimic expression, but rather an attempt to go further, which every human being can later amplify."

Other operations were more plastically aesthetic, like those of the British pair Gilbert and George who declared: "to be living sculptures is our vital blood, our destiny, our history, our disaster, our light and life"; or those of Luigi Ontani, Salvo, Urs Lüthi, and Katharina Sieverding. Some were presented in theatrical performances of rhythmic choreographed movement and music as with Trisha Brown, Rebecca Horn, Joan Jonas, and Giuseppe Chiari. Lastly, others were tied to a more interior, intimate but often violent sphere such as the works of Gina Pane, Marina Abramovic, Chris Burden, Dennis Oppenheim, and Bruce Nauman, or to the sociological, almost "political" one of Vito Acconci. Through their actions, performances, videos, and the imagery they produced, the body artists sought, through the truth of the artistic language, the much more profound truth of existence.

Narrative art, on the other hand, which took its lead from Conceptual Art and body art managed to transform the rigid conceptual definitions into rigorously narrative structures. It was adopted by some artists who created artworks by using sequences of photo-

graphic images with a narrative structure, the subject of which was the artist's own existence or a true fact extraneous to him. Among the most significant representatives of the movement were the Americans, David Askevold, John Baldessari, Bill Beckley, Peter Hutchinson, William Wegman, Roger Welch; the French, Annette Messager, Christian Boltanski, Jean Le Gac; the Germans, Bernd and Hilla Becker; the Italians, Franco Vaccari and Michele Zaza, as well as others who, by means of a narrative based on a combination of photographic sequences and texts, intended to show the brief episodes or fragments of everyday life that were tied to their own experiences, or to totally anonymous places and situations, so as to go beyond the tautological-conceptual definitions by means of narration and literature.

Hyper-Realism

In the United States, in the mid-1960s, at the same time that other movements were questioning the materials and techniques of art, a group of painters and sculptors developed the Hyper-Realist style. Their works were based on images of reality as seen through the photographic eye and were therefore highly detailed and painstakingly executed. Photography in fact could capture details of reality that not even the naked eye could see, and what is more it cooled the image through the technical process. Hyper-Realism took everything from the photographic image and rendered it through the use of artistic materials and techniques.

While according to the realists, especially with regard to painting, the object to be represented was nature, for Hyper-Realism, the object-model became a photographic image of reality. Hyper-Realism was a style that emerged in the United States during the second half of the 1960s, and was affirmed internationally at the VII Biennale of Paris in 1971 and at Documenta V at Kassel in 1972. By using a precise, meticulous technique to create images that were "more real than the real", hyper-real in fact, those artists produced paintings and sculptures in which no detail of reality was missing, details that at times not even the eye could see and only the photographic lens could capture. In their paintings, Malcolm Morley, considered the initiator of the style, Chuck Close, Richard Estes, Franz Gertsch, Don Eddy, John Kacere, Ralph Goings, Alex Coville, Robert Cottingham, Howard Kanowitz, and Richard McLean, and in the sculptures of Duane

Hanson and John de Andrea, using artistic techniques that were more and more sophisticated, reconstructed scenes of typically American daily life with photograph-like images and an exasperated technical virtuosity. Real forms were analysed through the camera lens in an aseptic, almost scientific manner, without the artist's emotional participation, and resulted in a formal reality that was so detailed and meticulous as to be unsettling. The images deriving from it provoked a certain sensation of uneasiness in the spectator because they revealed a hyper-reality that not even the eye could grasp, calling into question the science of vision and magnifying the qualities of each form. Some artists in Europe were also working along similar lines, although their work was different from their American colleagues in some aspects. In Germany, Gerhard Richter distorted the image optically, whereas Gérard Titus Carmel and Jacques Monory in France, and Francisco Lopez and Antonio Lopez García in Spain seemed more concerned with defining the form, and while their personal options differed, their departure point was always that of the photographic image. In Italy, the Roman Domenico Gnoli, who had for some time been working on the details of enlarged objects like shoes, buttons, and gloves, reproduced highly detailed fragments of different realities. His research was, however, entirely autonomous inasmuch as it was not based on photography, being more concerned with pictorial suggestions of metaphysical derivation.

Post-Modernism

"Post-modernism" began to be talked about in the late 1970s when it was first applied to a criticism of the modern movement in architecture. The term was used to describe a cultural period that started at the end of the 1970s and went on to characterise the following decade. Economics, philosophy, politics, sociology, architecture, design, information, advertising, and art reacted against the ideals of the modern, overthrowing them and in doing so turned everyday life itself into post-modern.

Towards the end of the 1970s, some critics and theorists began to maintain that modernism had died out along with the collapse of ideologies, the end of the "great stories" and the strong opinions that had characterised it. That criticism developed initially in the field of ar-

Robert Kushner,
The Double Ring,
1979.

Rodney Ripps,
Harlequin, 1981.

Jonathan Borofsky,
*Installation at the
Paula Cooper
Gallery of New
York*, 1980.

Sandro Chia,
Son of Son, 1981.

Enzo Cucchi,
Loreto Saint, 1980.

Francesco
Clemente, *Ring*,
1978-1979.

Mimmo Paladino,
The Great Cabalist,
1981-82.

Anselm Kiefer,
Nürnberg, 1982.

Georg Baselitz,
Male Nude, 1975.

A.R. Penck,
Untitled, 1982.

Robert Longo,
Untitled, 1981.

Keith Haring,
Untitled, 1982.

Tony Cragg,
Untitled, 1981.

Anish Kapoor,
Untitled, 1983.

Aldo Spoldi,
*Master Pulce –
The Hundred Years'
War*, 1980. Galleria
Giò Marconi, Milan.

Salvo, *Winter Night*,
1979.

Giuseppe
Maraniello,
Untitled, 1979.

Bruno Ceccobelli, *A*
New Underpainting
1984.

Carlo Maria
Mariani, *Dionysus*,
1985.

Gérard Garouste,
Untitled, 1981.

Carlo Bertocci,
The Flag, 1986.

Mark Kostabi,
Mass Production,
1990.

Plumcake,
Satan's Throne,
1985.

Cindy Sherman,
Bloody Mouth,
1985. Galeria
Monika Sprüth,
Cologne.

Peter Halley,
*Blue Cell with Triple
Contact*, 1986.

Jeff Koons,
Rabbit, 1985. Ileana
Sonnabend Gallery,
New York.

Janine Antoni,
Lick and Lather,
1993. Sandra
Gering Gallery,
New York.

Matthew Barney,
Drawing Restraint
7, 1992.

Dinos and Jake
Chapman,
Zero Principle, 1996
Galleria Giò
Marconi, Milan.

Paul McCarthy,
Bossy Burger, 199

chitecture, chiefly as a reaction to the modern movement, calling into question its basic principles, namely 1) the idea that every epoch had its own style, 2) history as a Darwinian succession of events, 3) formal and functional rigour, 4) simplicity, pureness, rationality and oneness. They opposed those principles with: 1)stylistic and linguistic multiplicity, 2) actuality as the oblivion of the past and the instant in which past, present and future unite, 3) the appearance of ornament and decoration, 4) complexity, multiplicity, contradiction, temporariness and nomadism.

In 1980, Paolo Portoghesi organised an exhibition for the architectural section of the Venice Biennale entitled "La presenza del passato – Strada novissima (The Presence of the Past – The Newest Road), in which architects and designers from all over the world presented projects that looked like film sets with hybrid multi-styled and hyperdecorated facades. In the works of authors like Alessandro Mendini of the Studio Alchimia (Adriana and Alessandro Guerriero, Andrea Branzi, Bruno and Giorgio Gregori, Carla Ceccariglia), Ettore Sottsass of Memphis (Gabriele De Lucchi, George J. Sowden, Matteo Thun, Aldo Cibic, Nathalie du Pasquier), and numerous foreigners, amongst whom, Hans Hollein, Michael Graves, and Robert Venturi, and other Italians like Aldo Rossi, Franco Raggi, Massimo Scolari, Franco Purini, Denys Santachiara, Paola Navone, the loner Battista Luraschi and still others, colour and synthetic materials were arranged like tesserae and used simply for appearance, for a purely decorative, aesthetic effect, that assembled the styles of the past into a redesign, or different repetition.

The American architect, Robert Venturi, was the first to design along those lines, while the French theorists Jean-François Lyotard and Jean Baudrillard elaborated the concepts of post-modernism. In his book, *The Post-modern Condition*, Lyotard maintained that man lived in a situation of constant crisis because [he was] "desperately overwhelmed by technology", therefore a confrontation with it placed him in the (post-modern) condition of having to continually review the entire history of modernism in the light of such elements. While the modern was characterised by categories like history, time, space and concept which were objective, the post-modern questioned such values and substituted them with one history, one time, one space, and one concept, which were more and more provisory and subjective, and in the last instance could only be legitimised by their own foundation and performance. In correspondence to all this was a subject that, abandoned by universal knowledge and the certainty of becoming an

objective of history and a prospect for the future, had to reconstruct a condition for itself that was no longer universal and objective, but particular and subjective, where the historical times of past, present and future were resolved in the "here and now" of actuality, in the instant of present time.

A radical change occurred in all the avant-garde, neo-avant-garde, and non avant-garde languages of art that had marked the twentieth century. The reaction was particularly against the artistic and cultural climate of the 1970s, dominated by the experiments of the Conceptualists, *Arte povera-ists* and behaviourists, all of whom were intent on a radical reduction of the artistic form. At the end of the decade there was a reappearance of colours, emotional states, and decorative elements, while the artist departed from a conceptual matrix, and returned to the traditional tools of painting (canvas, brushes, drawing and colour) that had been completely abandoned in the previous years. The image returned to art, a "happy" disenchanted image, that appropriated its own forms from history as well as from popular everyday culture.

Transavantgarde

Theorised in 1979 by the critic Achille Bonito Oliva and composed of the artists Chia, Clemente, Cucchi, De Maria, and Paladino, the Transavantgarde group reacted against the extreme immaculateness and rigour of the 1970s with a language that recovered painting and re-proposed the image by appropriating it from the history of art.

In 1979, Achille Bonito Oliva theorised, together with the artists Sandro Chia, Francesco Clemente, Enzo Cucchi, Nicola De Maria and Mimmo Paladino, a new way of making art to which he gave the name of Transavantgarde. The aim of those artists was to create a pictorial language that "knew how to return to its inner motives, to the reasons constituting its work, to its place par excellence" by which they referred to the place of the image, and painting, as a "continuous excavation inside the substance of the painting." Images converged in the Transavantgarde works, and those of Mimmo Germanà may be associated with them, that belonged to the history of art—above all to the "genius loci" of the history of art—to which the traditional tools of painting gave a new life. There was in fact a return to the pleasure of painting, to the joy of working with

that medium, in stark contrast with the rigid and analytical researches of the 1970s that, by privileging the conceptual aspects, effected such a radical reduction of the form as to make it disappear. The works of the Transavantgarde artists were oriented in the direction of a formal and chromatic opulence and, by drawing on the infinite repertoire of traditional forms, did not emphasis the intrinsic value, the signified, as much as the pleasure of the pure pictorial form, the signifier.

The artistic activity in Germany at the same time was comparable to that of the Transavantgarde.

The Neue Wilden (New Savages) movement that emerged in Berlin in particular was a clear reference, both theoretically and formally, to the Expressionist painting of the beginning of the century. The pictorial plane was attacked with violent, decidedly expressionist brushwork, and pervaded by an existential fury in which the figurative and technical references were of obvious Expressionist derivation. The difference between the New Savages (Rainer Fetting, Helmut Middendorf, Bernd Zimmer, Castelli/Salomé, etc.) and the German Expressionists consisted in the fact that while the pictorial violence of the Dresden group corresponded to a real social criticism as well as an aesthetic factor, the pictorial violence of the Berlin artists was strictly an aesthetic fact and devoid of any ideological meaning.

In addition to them, indeed preceding them chronologically, were other artists like Anselm Kiefer, A.R. Penck, Georg Baselitz, Markus Lüpertz, Jörg Immendorff, K.R. Hödicke, Gerhard Richter, and Sigmar Polk. Both the sign and the material, and figure and space, assumed strong formal values in their paintings due to the extraordinary dimensions of the works which involved the space by dominating it physically and emotionally.

Graffiti Art

In the beginning of the 1980s, a proliferation of new signs, technological and metropolitan, appeared almost everywhere seeking out new spaces for action (billboards, underground trains, abandoned buildings). It was in New York, however, that graffiti art, however, developed and gave a new identity to the artist who, working outside the traditional techniques and places of art, confronted himself and his own sign with the countless signs and places of the city.

In the early 1980s, the phenomenon of graffiti art exploded in New York, and soon spread to the rest of the world. The most outstanding representatives of the movement were Keith Haring, Jean-Michel Basquiat, A-One, Futura 2000, Ronnie Cutrone, Ramel-lzee, Ero, James Brown and many others, and in Italy, Francesca Alinovi. Originating in the ghettos and streets of the Bronx and Brooklyn, those "low" culture artists covered the billboards of the city and then its subway trains with their exuberant sign-painting before moving into museums and galleries. The signs they produced, however, no longer had any ideological value or were a social protest which had in the past characterised that form of expression. They had simply become a search for an artistic language in which the signifier did not refer to a signified. The sign was anarchic and technological, both in its structure and the materials used (aerosol spray paint and indelible felt-tip pens), departing from reality in order to confront it. It was a "frontier art", as Francesca Alinovi has pointed out, "that was placed in the intermediate space between culture and nature, mass and elite", which tried to dialogue with other artistic expressions through the use of irony. Signs and letters, and figures and "tags" mingled in American graffiti as they incessantly proposed not only new signs and scenarios but above all new subjects which could act freely within the infinite signs that were continually being created by high and low culture.

Offshoots of Post-Modernism

Post-modern art reacted to the theoretical and formal rigour of modern art by recovering the apparently traditional techniques of painting and sculpture. By means of those media, the imagery of the art of the past was reviewed in a total subversion of finalities. While the rationality of the modern art concentrated on the sense and profundity of the thing, post-modern art was more concerned with a different reassessment of the appearance, the facade, or the simulacrum, for which it was often useless to ask for a meaning. The "beautiful" that art was seeking seemed to justify itself.

Following the crisis of modernity, post-modernism emerged as an avant-garde language, since the answer that the artists and theorists had given to the fall of modern ideals still bore the characteristics of objectivity and universality. Some American artists during the mid-

1970s, in anticipation of such a climate, reacted to the excessive stripping down and asceticism of the art of the times with what they described as "pattern painting." Among those were Robert Kushner, Valerie Jaudon, Brad Davis, Kim MacConnell, Rodney Ripps, Ned Smith, Robert Zakanitch, Tina Girouard, Tommy Laganan-Schmidt, and Joe Zucker. Their works contrasted sharply with the forms of Minimal and Conceptual Art, and favoured a more decorative character. Floral or geometric decorations created with a wide variety of materials (sewn coloured fabrics, painted canvases, decorative or practical objects, pottery, synthetic materials, etc.) appeared on the scene to contrast with the currently dominant, severe forms.

Throughout the world, post-modernism gave rise to heterogeneous and multi-stylistic groups. The New Image Americans, Jonathan Borofsky, Neil Jenney, Nicholas Africano, Susan Rothenberg, and later Robert Longo, David Salle, Jack Goldstein, Sherrie Levine, Thomas Lawson, Troy Brauthauch, and Julian Schnabel returned to painting as a practice conveyed by technological images. These artists substituted the real world with a fictitiously adventurous world of appearances and mass media imagery.

Around the mid-1980s, Peter Halley, Allan McCollum, Peter Schuyff, Haim Steinbach, Jeff Koons, and Ashley Bickerton produced paintings and sculptures of Pop derivation in which they made use of both figurative and geometric elements.

In Italy, in addition to the Transavantgarde which was then operating at an international level, the groups of the Nuovi-Nuovi (New-New Ones), Anacronisti (Anachronists), and Nuovi Futuristi (New Futurists) were elaborating their own languages.

The Nuovi-Nuovi artists, backed by the critics Renato Barilli, Francesca Alinovi and Roberto Daolio, though dissimilar from a formal point of view, were eclectic both in their styles and contents. They included Salvo, Luigi Ontani, Luigi Mainolfi, Aldo Spoldi, Antonio Faggiano, Luciano Bartolini, Giuseppe Maraniello, Wal, Bruno Benuzzi, Marcello Jori, Giorgio Pagano, Felice Levini, Giuseppe Salvatori, Enrico Barbera, and they were later joined by Enzo Esposito, Giuseppe Del Franco and Carlo Bonfà, and the group of the New Futurists. The Nuovi-Nuovi concentrated on theoretical and formal elements appropriated from the past and based on the notion of "different repetition" or redesign which could occur in a variety of ways. Their work was light in spirit and disenchanted, and they lived post-modernism as a "gay science" that was open to a myriad of possibilities. Painting for them was not just a matter of "dirtying their hands"

or living the material first-hand, but rather carrying out provisory inventions in order to create appearances.

Those dynamic, open-ended elements were picked up by the Nuovi Futuristi, represented by the Plumcake group (Gianni Cella, Romolo Pallotta, and Claudio Ragni) as well as by Gianantonio Abate, Clara Bonfiglio, Innocente, Marco Lodola, Luciano Palmieri and Umberto Postal. By the use of technologically advanced tools (fibre glass, and synthetic paints and materials) and by questioning the traditional forms and techniques of art, they opted for the use of design, decoration and everyday objects in their works.

The Anacronisti (also called Appropriation, Hyper-Mannerism or Cultivated Painters), on the other hand, appropriated the techniques, forms and styles of Classical and Romantic painting and reinterpreted them in a contemporary key. Backed by the critics Maurizio Calvesi, Italo Mussa and Italo Tomassoni, they included Carlo Maria Mariani, Alberto Abate, Roberto Barni, Ubaldo Bartolini, Carlo Bertocci, Lorenzo Bonechi, Stefano Di Stasio, Omar Galliani, Franco Piruca, together with Jean-Michel Alberola and Gérard Garouste from France.

Almost in contradiction to their researches, which were involved with the recovery of the pictorial plane and the use of historical imagery, was the "primary magic" theorised by Flavio Caroli and represented by numerous artists, amongst whom, Davide Benati, Nino Longobardi, Stephen Cox, Gianfranco Notargiacomo and Valerio Cassano. Their concern was to recover that profundity in the artwork that was rooted in psychoanalysis and the archetypal material of the collective unconscious.

Close to their position in some aspects was the work of some artists of the so-called "New Roman School": Gianni Dessì, Bruno Ceccobelli, Domenico Bianchi, Giuseppe Gallo, Piero Pizzi Cannella, Nunzio, Marco Tirelli, Pietro Fortuna, and Luca Saint Just. In their works, the pictorial or plastic medium attempted to seek out its own profound potentialities of expression.

Significant research was carried out in Great Britain in sculpture in particular, and made its appearance in the works of artists like Tony Cragg, Anthony Gormley, Bill Woodrow, Julian Opie, and Anish Kapoor. By continuing the British artistic tradition which was characterised by the investigation of the plastic medium, those artists created works which, by employing found materials for the most part as in the case of Cragg and Woodrow, revealed their profound knowledge of that medium, and achieved an extraordinary formal equilibri-

um. Reinhard Mucha and Thomas Schütte in Germany and John Armleder and Fischl & Weiss in Switzerland confronted the plasticity of the work in the same way while adopting original compositional solutions, whereas Jiri Georg Dokoupil and Walter Dahn follow a more conceptual line albeit one that was based on manual execution. Other Germans, Werner Büttner, Albert Oehlen and Martin Kippenburger have absorbed a Neo-Expressionist approach from their teacher Sigmar Polke.

In France, the works of the Figuration Libre (Free Figuration) artists, Jean-Michel Alberola, Jean-Charles Blais, Robert Combas, Hervé Di Rosa, and Remy Blanchard, which borrowed from more recent movements ranging from the Transavantgarde to graffiti art, as well as from the Art Brut of Dubuffet and that of the CoBrA group, were markedly chromatic, stereotyped and gestural in style. Post-modernism, which characterised the decade of the 1980s, brought a breath of fresh air and eclectic freedom to the world of art, making it possible for artists to do what they pleased in the way they chose.

It was almost inevitable that there would be a reaction to such stylistic exuberance which became more and more markedly subjective. Between the 1980s and 1990s, a group of international artists (in Italy, Premiata Ditta sas, Oklahoma srl, and Tecnotest; in Holland, Int. Fish-handel Servaas; in Germany, Ingold Airlines; in the United States, Kostabi World, and close to it the research of Bertozzi & Casoni snc), introduced in part by the work of the Belgian Guillaume Bijl and the French Philippe Thomas, countered with commodification in which art, the organisation of art, and reality interacted. The movement—particularly significant in Italy where it was theorised by this writer under the logo "Arte & Co" and analysed in a book of the same title, and in Holland under the aegis of Frans Haks where it is called "business art"—aimed at making post-modernism return to avant-garde problems by revolutionising the management of the artistic work: gallery, museum, and critic were no longer the finalities of art, but its instruments. In that way, new artistic subjects known as "companies" were created. In those artist-company operations, the materials of the world reappeared to be used again in operations like market surveys, financial bids, and the production of industrial objects. All the elements of the artistic system became the objective base of their operations in their work. The museum like economics, sociology, and finance became a material to be used as an artistic instrument.

Even the media art that began to emerge around 1989, theorised by

Gabriele Perretta, was represented by a large group of painters including Gian Marco Montesano, Kathe Burkhart, Sergio Cascavilla, Santolo de Luca, Enrico De Paris, Mark Kostabi, and Gabriele Lamberti. Their works proposed imagery relative to the complexity of culture and reality as seen through all the interference and interaction occurring at the level of communications. By working on images fluctuating from one territory to another and from one time to another, those artists resolved the problem of multiple interference between one medium and another, and between the medium and reality in the very instant the work was ideated.

Close to the media artists were the Italians, Cesare Viel, Emilio Fantin, Formento-Sossella, Tommaso Tozzi, Luca Vitone, Nello Teodori, and many foreigners, Americans in particular, whose work employed technological instruments ranging from communications and organisation systems to computers and the Internet.

In conclusion, Jeffrey Deitch's interesting comments about "post human" are worth mentioning, in which speculations regarding the complexity of post-modernism, its typical materials, and mass media interactions were applied intelligently to the human body which was considered a ready-made. In the works of Jeff Koons, Matthew Barney, Paul McCarthy, Mike Kelly, Damian Hirst, Kiky Smith, Cindy Sherman, Janine Antoni, Jake and Dinos Chapman and others, the body was experienced as an appearance, artifice, or graft on which aesthetics and technology acted, but also as the re-composition and re-formation of a new subject, the new ego.

The Contemporary Period

The search for a new ego seems to be the current theme. The 1990s have been characterised by a proliferation of themes of subjectivity about which it is difficult to speculate, and which do not refer to the concepts and forms of history usually adopted by art criticism. This subjectivity seems to refer for the most part to the individual citizen's legal right to be able to live creatively.

More than by art theories or research, the current art scene seems to be distinguished by the indiscriminate ability of the individual to say what he wishes without any concern about adhering to theoretical or formal rigour of an objective nature. The young artists who are working today (and here we are referring to the Italians in particular) find themselves acting in a reality or a system that is more and more mobile and provisory, a continuous, fluid, unpredictable chain of events,

that offers neither support nor certainties. This situation first emerged in Italy, in particular in Milan, in the mid-1980s when a group of artists gathered around the figure of the artist and intellectual Corrado Levi. Included in their ranks were Stefano Arienti, Mario Dellavedova, Amedeo Martegani, Massimo Kaufmann, Marco Mazzucconi, Pierluigi Pusole, Bruno Zanichelli, Umberto Cavenago, Roberto O. Costantino, Carlo Ferraris, Maurizio Arcangeli, Marco Cingolani, Dimitri Kozaris and others. They began to show in the many galleries that had opened throughout the city, above all in Levi's studio, and in an exhibition that Giò Marconi organised in the unused space of Brown-Boveri in Milan in 1986. Presented as the artists of the 1990s, their work was often dissimilar, heterogeneous, indeed often in opposition.

No longer organised in groups, tendencies or schools of the avant-garde type, in search of an objective language, they found themselves in groups of a logistic or generational order.

Among the precursors of such a tendency were the variegated East Village group of New York (Richard Hambleton, Rhonda Zwillinger, Mike Bidlo, Ronnie Cutrone, and Arch Connelly) who in the early 1980s raised the issue of art in terms of subjective creativity, and also Dominique Gonzales-Foerster, Manuel Ismora, Bernard Josten, Pierre Joseph, Philippe Parreno, Philippe Perrin, and Cercle Ramo Nash in France whose artistic sensitivity was based on a subjective creativity and an innovative language that lay between fiction and reality. In Italy, on the other hand, even the groups that shared a common theory, like the Piombinesi (Cesare Pietroiusti, Salvatore Falci, Giuseppe Modica, and Stefano Fontana), backed by the critic Carolyne Christof-Bakargiev, or the Milanese Casa degli Artisti and Lazzaro Palazzi (Liliana Moro, Bernard Rudiger, Mario Airò, Luca Quartana, Adriano Trovato and Stefano Dugnani) were influenced by this subjective climate in the names they chose, in some cases connected to their places of work, as with the Florentine group of Daniela De Lorenzo, Carlo Guaita and Antonio Catelani.

In a reality that was or was not artistic, more and more fragmented, and distinguished by a total eclecticism outside of any linguistic logic, the most disparate proposals were presented. They ranged from those of political and social commitment to reflections about museums or the use of the artwork, as in the case of some foreign artists like Cady Noland, Sophie Calle, Jenny Holzer, Andres Serrano, and Bert Theis, to a commitment of feminist nature, or one that harked back to a dimension that was more intimate, private, domestic and based on indi-

vidual survival (Barbara Kruger, Rosemarie Trokel, Katharina Fritsch, Annette Lemieux, Vanessa Beecroft, Betty Bee, Grazia Toderi, Eva Marisaldi, Sylvie Fleury, Abigail Lane, Mariko Mori).

Although their content may have had to do with social problems or subjective ones, it still remains difficult to give a label to the works produced during the 1990s inasmuch as they do not seem to have the specific characteristics of a language, but perhaps it is because of this that these proposals are so timely and interesting, corresponding as they do to the expectations of the world. Every artist, just like every citizen, observes the world within and without. He tries to bring back to the artwork a combination of sensitivity and emotivity rather than an objective vision of reality or an answer to the world, analysing it through the spirit of research that has always marked the avant-garde, as in the case of the Germans, Franz Ackermann, Michel Majerus, Robias Rehberger and others.

The techniques that are used range from the most traditional, like painting and sculpture, to the most technological, like photography, video, cinema, computer, up to the Internet which permits for the interaction of a myriad of subjects by means of a capillary network.

Today the banal, the ordinary, the commonplace, one's secret world, and the necessity to survive take precedence over the search for the slightest assurance or legitimisation that one would hope to find among what remains of a reality and an artistic system that are about to undergo a radical change. In actuality art seems to be open to everyone: it is within everyone's reach, accessible to one and all, not only as a timid observer but as a protagonist or haughty artist, in an almost "do-it-yourself" that heeds no rules save that of one's own private and personal pleasure.

In this sense, the entire system of art (museums, galleries, critics, publications, etc.) has become a manual of individual creativity which has little or nothing to do with the research that has characterised modern and post-modern art. The objective, universal and all-encompassing languages of the historical avant-gardes at the turn of this century, and their subsequent revival on the part of the Neo-avant-gardes during the second half of the century have been substituted by an incessant, private, subjective chatter that has no scope other than to satisfy itself. It is the private pleasure of one who wants to say his own thing, and in doing so, does not seek the objective language of art as much as his own personal survival, as is the case of Maurizio Cattelan, Filippo Falaguasta, Vedova Mazzei and Sukran Moral.

There are no more universal and objective visions of the world, and

therefore of art, to which to aspire. No longer is the artwork the result of knowledge or an action that at times has grazed heroism, by which the artist has pretended to resolve the destiny of art and of the world. There are cases of artists who are against such a system, and do not hesitate to announce the end of modern art, like the Russian Alexander Brener. The only thing that one hears today is a multitude of words which are only concerned with subjectivity, and expect nothing in return except perhaps an answer from another source of subjectivity.

As a consequence, post-modernism is to be considered the last avant-garde. As a matter of fact, what has come afterwards is still searching for a reference that will legitimise its historical mandate. In this way, an everyday culture has emerged which is in total antithesis with the historical model. On different occasions, I have defined this situation as "everyday art." Everyday art is that of the citizen-artist rather than of the artist-scholar, it is a freely creative art rather than professional art, it is the art of slick magazines rather than historical art, it is "do-it-yourself art."

These days movements no longer present themselves which aim to change the world as in the case of the historical avant-gardes, or to work on the artistic form as in the case of the Neo-avant-gardes. What has emerged above all are individuals who treat the adventure of art as an adventure in everyday survival. If the parameters of judging the art system today are really based on performances, then the corresponding artworks can be neither true nor beautiful if no tangible work is produced as a result. What is particularly disarming for this writer is to make recommendations following such a system of judgement, since there is more of a need for a market survey than for a critic. There are, in any case, artists who, when questioning themselves about the new concept of utility introduced into the system, keep such elements in mind in their works, and they do represent a good-sized group. Their real names are often concealed behind a pseudonym or a logo, as if they wished to remain clandestine as they speak the truth, reciting the end of the history of art of this century. This is the case of the Brigade ES or the Super-heroes who, aware that the critical aims of modern art have reached a dead point, intend to start from zero. Like others, they no longer live their own bodies as ready-mades but, on the contrary, as citizens who question the ready-made: only here can we still find a distinction between art and free creativity. The world that has always been more interested in idle talk will almost certainly say we are wrong, but it cannot deny that these artists represent an unknown in the system of art.

General Bibliography

AA.VV., *The Art of the End of Mille-nium*, Taschen, Koln 1999.

Arnason, H.H., *History of Modern Art*, Thames & Hudson, London 1969 – Abrams, New York 1969.

Battcock, Gregory (ed.), *Idea Art, A Critique*, Dutton, New York 1973.

Chipp, Herschel B. (ed.), *Theories of Modern Art*, University of California Press, Berkley 1968.

Dunlop, Ian, *The Shock of the New*, Weindenfeld & Nicolson, London, 1972 – American Eritage Press, New York 1972.

Greenberg, Clement, *Art and Culture: Critical Essay*, Beacon Press, Boston 1961 – Thames & Hudson, London 1973.

Hughes, Robert, *The Shock of the New*, Brithish Broadcasting Corporation, London 1980.

Hulten, Pontus, *The Machine as Seen at the End of the Nechanical Age*, MO-MA, New York 1968.

Kramer, Hilton, *The Age of the Avant-Garde*, Farrar, Straus, New York.

Lippard, Lucy, *Six Years: The Demate-rialisation of the Art Object from 1966 to 1972*, Praegerm, New York 1972.

Lucie-Smith, E., *Arte Oggi*, Mondado-ri, Milano 1976.

Rose, Barbara (ed.), *American Art sin-ce 1900: A Critical History*, Pareger, New York 1975 – Thames & Hud-son, London 1975.

Rose, Barbara (ed.), *Readings in Ame-rican Art since 1900: A Documentary Survey*, Pareger, New York 1968.

Rosemberg, Harold, *The DE-Defini-tion of Art: Actin Art to Pop to Earthworrks*, Secher & Warburg, Lon-don 1972 – Horizon Press, New York 1972.

Rosemberg, Harold, *Discovering the Present: Three Secade in Art. Culture and Politics*, University of Chicago Press, Chicago & London 1973.

Rosemberg, Harold, *Art on the Edge: Creators and Situation*, Macmillan, New York 1975 – Secker & Warburg, London.

Rowell, Margit, *The Planar Dimen-sion, Europe 1012-1932*, Guggenheim Museum, New York 1979.

Shapiro, Meyer, *Modern Art, 19th and 20th Centuries: Selected Papers*, Brazil-ler, New York 1978.

William, G. (ed.), *Cream – Contempo-rary Art in Culture*, Phaidon, London 1998.

Argan, Giulio Carlo, *L'arte Moderna 1770/1970*, Sansoni, Firenze 1970.

Index